Irreversible

✖ Controversies

Series editors: Stevie Simkin and Julian Petley

Controversies is a series comprising individual studies of contro-versial films from the late 1960s to the present day, encompassing classic, contemporary Hollywood, cult and world cinema. Each volume provides an in-depth study analysing the various stages of each film's production, distribution, classification and recep-tion, assessing both its impact at the time of its release and its subsequent legacy.

Also published

Jude Davies, *Falling Down*
Shaun Kimber, *Henry: Portrait of a Serial Killer*
Neal King, *The Passion of the Christ*
Peter Krämer, *A Clockwork Orange*
Gabrielle Murray, *Bad Boy Bubby*
Stevie Simkin, *Basic Instinct*
Stevie Simkin, *Straw Dogs*

Forthcoming

Lucy Burke, *The Idiots*

'The Controversies series is a valuable contribution to the ongoing debate about what limits – if any – should be placed on cinema when it comes to the depiction and discussion of extreme subject matter. Sober, balanced and insightful where much debate on these matters has been hysterical, one-sided and unhelpful, these books should help us get a perspective on some of the thorniest films in the history of cinema.'
Kim Newman, novelist, critic and broadcaster

Irreversible

Tim Palmer

 macmillan
education palgrave

First published 2015 by
PALGRAVE

Palgrave in the UK is an imprint of Macmillan Publishers Limited, registered in England, company number 785998, 4 Crinan Street, London N1 9XW

Palgrave Macmillan in the US is a division of St Martin's Press LLC, 175 Fifth Avenue, New York, NY 10010.

Palgrave is a global imprint of the above companies and is represented throughout the world.

Palgrave® and Macmillan® are registered trademarks in the United States, the United Kingdom, Europe and other countries.

ISBN 978-0-230-33697-1 ISBN 978-1-137-47862-7 (eBook)
DOI 10.1007/978-1-137-47862-7

A catalogue record for this book is available from the British Library.

A catalog record for this book is available from the Library of Congress.

For Liza
Once again, always

Contents

List of Figures

Acknowledgements

I would like to thank my editors, Stevie Simkin and Julian Petley, for commissioning this book – the first in the Controversies series to focus on a French film – in the first place, then for all their support and editorial flexibility as life intruded in the early years of this book's gestation. As with all my work, I am grateful to the energetic staff of the Bibliothèque du film and the Cinémathèque Française for their help during my research stays in Paris. I'm also grateful to the French filmmakers who, over the years, have agreed to be interviewed by me, most recently Carine Tardieu in July 2013, for an excellent conversation, in passing about Gaspar Noé's producer.

Thanks to my home institution, the University of North Carolina Wilmington, for a slew of research awards, notably a Charles L. Cahill grant and a Summer Research Initiative, to help make this book possible. The contributions of the Office of International Programs, for a series of travel grants, were vital. Thanks to my chair in Film Studies, Dave Monahan, at the helm while this book took shape, whose help is always appreciated. Thanks to the indefatigable Pat Torok and superb Jamie Hall for the logistical backup during my regular work, and especially for helping organize my various work trips to France. I'd also like to acknowledge the terrific students I've been fortunate to have in recent years in my FST 384: Contemporary French Cinema classes, especially for our memorable sessions on *Irreversible* and its neighbours, battles well joined. Thanks elsewhere to Tara Ferguson, for battening down the hatches, and to Kelley Conway and Richard Neupert.

Closer to home, I feel much gratitude for my family in my adopted homeland, America. Thank you, Betty and David Shippey, for all the support over the years. To my newly seven-year-old son, Riley, customarily asking me what I'm doing as I sit at my laptop, typing away, surrounded on all sides by DVDs, books, notes and printouts, thank you for your constant curiosity, energy and the happiness you bring to my life. The afternoon when we

chatted about what writing a book meant, and why people do it, will live long with me. ('But the next one won't take as long, right, Daddy?')

My final thanks is for my wife, Liza, who even makes a cameo in these pages. In many ways this book is a summing-up of a long period of research into French cinema, making writing it inseparable from all the film screenings, festivals and conversations we've had in our lives over the years, a dialogue begun many years ago in Madison that hasn't stopped since. If marriage can in part be defined as a conversation, then ours has been rich beyond compare. On a smaller-scale note, though, I especially appreciate that evening in 2003 when we staggered out of the Curzon Soho, in London, feeling sideswiped by cinema yet again. Liza, I hope you know how grateful and happy I am for our years together, and how much everything I do builds from your support and your wonderful role in my life. Thank you for everything.

Preface: *Irreversible* and Me

For a film about ghastly pursuits, two among them especially depraved, it seems like *Irreversible* has been following me for some time now. I first saw the film during a visit to London in 2003, at the Curzon Soho theatre, a technically superior venue that proved well equipped to unleash Gaspar Noé's cinematic arsenal. I still remember that actual screening vividly, in and of itself quite a rare thing for the habitual filmgoer: how the unoccupied seats shook during the deepest bass rumbles; the sense of dread aroused by the droning electronic barrage in the opening title sequence; and how the small audience (minus a couple of walkouts) stumbled into the hallway afterwards in a visible state of shock, several lighting cigarettes immediately, in defiance of house rules. My wife, Liza, alongside me that evening, was herself just as shaken as I was; I felt a tinge of guilt for having brought her to yet another grim French film. But she herself soon reassured me, convinced me really, that she was actually glad to have seen something that extraordinary. This unflustered reaction reminded me – and here came the glimmerings of empathy for Noé's work – of Liza's longstanding interest in avant-garde cinema. One of the first films we had seen together was, of all things, Peggy Ahwesh's *The Deadman* (1987) in the Student Union of Madison, Wisconsin, where we'd met while studying for graduate film studies degrees. After that night at the Curzon, the sneering dismissals I began to read about *Irreversible*, its rapid promotion to the status of *film maudit*, seemed to me hasty, clouded by prejudice. Most critics were disconnected from an intrinsic pure quality of cinema I'd come to value if not necessarily enjoy: its capacity to render vicarious sensations instead of habituated predictable narratives, to humble the spectator before stimuli that might just prove indelible. For the first time I found myself cast in the unwanted position of defending, explicating or at least contextualizing such a problematic and undeniably troubling piece of cinema. I recalled an old quote about Stanley Kubrick – whose work was clearly vital to *Irreversible* – that you didn't just see one of his films, you invited it into your life.

Irreversible demands that we think backwards and forwards, and in retrospect Noé's film was a major cue – perhaps better described as a challenge, a gauntlet blow to the face – in my path towards studying, writing about and teaching contemporary French cinema. Ironically, given the film's entropic slogan that 'Time Destroys All Things', it was *Irreversible* that accelerated my fascination with, and investment in, a country that could produce such a film, that housed such an iconoclast as Noé. Compelled despite myself, I had to work out where this film had come from, and why. That period, lasting about seven years, culminated in my first book, *Brutal Intimacy: Analyzing Contemporary French Cinema* (2011). With *Irreversible* lurking in the wings, the project grew to explore how diverse French cinema had become in the twenty-first century, a rapid evolution into the most stimulating, certainly the most ingenious, production centre on the planet. At first glance *Irreversible* might appear to be a renegade production, I concluded, but it was just one (sharp) voice among many in a series of ongoing conversations, fostered by the film-making system that France so carefully nurtured. Whenever I now teach a class about contemporary French cinema, or program film series and screenings, I use an analogy to explain this situation. Today French cinema isn't just a calculating industry or a rarefied art form: it's a genuine ecosystem, with all the sprawling resources that term implies.

However distinctive *Irreversible* remains, therefore, to me it was a quintessentially French production. The film is uncompromising, born of hybrid film-making tendencies in uneasy combination, aggressively youthful, intensely corporeal, technically bravura, designed to unsettle rather than soothe, at a certain point inspiring as well as appalling, an impassioned ode to a twisted version of modern Paris. In some ways *Irreversible* inherits and adopts its French materials defiantly; in others, it angrily shrugs them off. But then and now *Irreversible* reflects how the French cinema ecosystem strives to sustain and renew itself, innovating constantly, bustling with energy. Proximate currents to Noé's initial career, many bolstering *Irreversible*, as we will see, thus issue from the interrelated engines of

France's production model, its turbines. Context to *Irreversible*'s youthful
agenda is France's *jeune cinéma*/young cinema mantra: the fact around 40%
of its films each year are made by first-timers, the product of grant-giving
and State interventions that are a legacy of the infamous 1950s French New
Wave vanguard; the majority of these debutants now also make follow-ups.
Standing alongside Noé, creatively and professionally, is his life partner,
Lucile Hadzihalilovic, a reminder that in the early twenty-first century
more women (in a good year, around a quarter of all annual French feature
directors are female) make film-making their business in France than have
done anywhere else, ever. In part, this is because of recruitment drives among
French film schools – another crucial aspect of Noé's career – that are, yet
again, some of the best you can hope to find, with coveted resources and
dedicated students and teachers. These film instructors, moreover, whose
ranks have now since been joined by Noé, believe that film-making should
derive from classes that conflate critical-historical studies with technical
practice. In sum, everywhere you look the French film ecosystem yields
dividends like *Irreversible*. France cultivates some of the most idiosyncratic
and adventurous star performers; it has resurgent animation and digital
sub-industries; it makes popular genre films from small-scale comedies
to policier procedurals and bloated spectaculars; it maintains a circuit for
shorts and micro-documentaries; it nourishes a population of committed
avant-gardists. Whatever you might like about moving image media, it's
happening in contemporary France, often in strange and engaging new
permutations.

At the heart of all this, though, is the fact that *Irreversible* really is a
tissue of reworked citations, a hard-to-classify mutant production, a complex
of revived cinematic practices old and new, French and international. The
matter of *Irreversible*'s variegated constitution, derived from Noé's applied
cinephilia, was what I felt the first wave of critical respondents importantly
missed. And this advanced French cineliteracy truly is ubiquitous: it
permeates the groundwater, manifesting constantly. You see it in the form of
French film-makers artfully combining methods traditionally at odds with

one another – like crossing mainstream genres with high art intellectualism, or applying certain devices of experimental film-maker Michael Snow's cinematography to rape-revenge narratives. Or else there is the demanding French film reception circuit: passionate critics and scholars demanding rigour from their film-makers in pressure-cooker interviews about difficult texts; a situation in which film-makers like Noé are expected to stand trial, to account for such discomfiting screen policies; ongoing debates based on the energy of believers convinced a priori that film matters. And then there is the Parisian compound of artful programming (a city still a filmgoer's paradise) that makes almost all types of film accessible to everyone, to watch and learn: from obscure revivals playing at tiny historical one-screen 35mm throwbacks on the Rue Christine, to the new sprawling subterranean Bercy Ciné Cité megalopolis, to, just five minutes' walk away, the world's finest repertory venue, the Cinémathèque Française, whose choice of screening series remains as deliciously unpredictable as ever, like Henri Langlois never died.

Writing all this up, I picked for *Brutal Intimacy*'s cover one of contemporary French cinema's more arresting, yet somehow representative, compositions. The shot I chose came from *Irreversible*, and Noé's film again

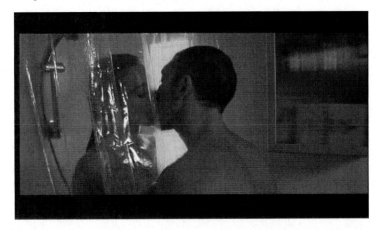

Figure 1: Alex and Marcus kiss through a shower curtain in segment 11 of *Irreversible*

stole into view, a mother lode of materials, an unpredictable flagship text. The image was of Vincent Cassel and Monica Bellucci kissing passionately through a translucent shower curtain, just before their characters part, a climactic romantic idyll near the film's end/beginning. Weirdly affecting, Noé's Cassel–Bellucci kiss is stunningly lit and staged: its tactile backdrop is of dank green walls, spraying water drops hitting bathroom tiles; these two poised naked bodies are entwined with glowing warm flesh tones, a sallow white rectangle of diffused light from a rear window offsets and frames the angled faces. Noé's mise-en-scène is of tangible impromptu mutual desire in a beautifully dank washroom, a piece of Robert Doisneau happenstance morphed into a densely rendered twenty-first-century interior. There's also a distantly refracted mordant cinephile joke at play: in a film as much concerned with female degradation as Alfred Hitchcock's *Psycho* (1960), Noé wants here to make a woman in a shower erotically resplendent again, a body in communion not alone, an agent of her destiny not a victim, an antithesis rather than a preface to horrible murder. Noé's shot, moreover, again in contrast to the archly formalist Hitchcock, is a rare filmed set-up that radiates complete intimacy; it exudes the improvised qualities of two people utterly at ease with one another, comfortable in their own skins, together. (I've long since thought that one of a film-maker's greatest challenges is to convey successfully the ingrained passions of a couple, as if they were emotionally as well as physically conjoined, spiritual twins, meant to be together, destined for each other; *Irreversible* is after all in its own grotesque way a romance: in its inverted order, its actual screen duration, it becomes a tale of a man and a woman lost and destroyed that wind up finding each other and utopian release.) Noé's shot is, in addition, a showcase of two of world cinema's most memorable-looking star performers, a duo at the time, married off-screen and frequently tenderly engaged on-screen; yet this is also an abnormal, even off-putting culmination of post-coital euphoria: mouths meeting in blissful union, two bodies kept apart by a soaked plastic sheet; Bellucci looks almost shrink-wrapped. This one image, I felt in retrospect, went some way towards summing up the bizarre

creativity, the full gamut of materials on offer for the engaged viewer, the artful colliding juxtapositions within contemporary French film.

From there, *Irreversible* continued to muscle in on the conversation, to dominate proceedings. Reviews of *Brutal Intimacy* trickled in, and most attention focused on what I'd called the *cinéma du corps*/cinema of the body, of which *Irreversible* was a prime example. People (especially academics) tended to be suspicious, taken aback, but that one section of the book cast a shadow over everything. When I was fortunate enough to be invited to do some interviews about the book, *Irreversible* inevitably led off, and shaped, the questions and answers that followed. Why *that* film? Why would you discuss it, put it so emphatically on view? Try as I might to point elsewhere, *Irreversible* galvanized respondents. At the same time, the university class that grew up around the book gave *Irreversible* perhaps its most satisfying, surprisingly sympathetic platform, a station finally to be objectively regarded, catalogued, appreciated for what it was. Tentative to begin with, for the first time in my career I started screening Noé's film with a disclaimer beforehand, but few students ever wound up leaving the theatre. Many told me afterwards that they'd always wanted to see *Irreversible*, had long since heard about its rewards and perils, but this was the moment when they finally took the plunge. I always consider a successful class one that doesn't end, when dialogue goes on outside the classroom, and here *Irreversible* wound up an unexpected champion. Students of different ages, backgrounds, genders and sexual orientations all found something to fascinate, lingering a long time after the abrasive miniature flicker film with which Noé concludes. Numerous students would end up writing about Noé, feeling something akin to my reaction years earlier in the Curzon Soho. This urge persisted: to figure out just what had been done to them, hyperbole aside, to consider fully the cinematic broadside through which they had just passed. Better still, when my university seminars culminated in film series, bringing new French 35mm prints to campus, my students voluntarily took to programming some of *Irreversible*'s closest peers, related *cinéma du corps* productions. At one such session in 2007, Bruno Dumont's *Flanders*

(2006), introduced by two undergraduates, played to a crowd of nearly 300; a decent number applauded afterwards. Something about *Irreversible*, it seems, demanded that a cinephile try to analyse its impact, to pass it along and expose others, to study it from a range of different viewpoints, to assess where it came from, to generate a conversation.

These are the range of instincts I aim to explore in this book. Looking at Noé's emergence as an auteur, his defining commitments, I will also take care to place his career in the contexts, the generative mechanisms of contemporary French cinema inside and outside of which he operates. Noé's configuration comes from larger-scale tendencies, institutional French mandates, but also from a smaller-scale conversation within French and international film culture, spirited group interactions generated before and after a project as incisive as *Irreversible*. In and around the actual film, in addition, we'll also assess its group authorship, involving the defining contributions of collaborators from Benoît Debie, Noé's image consultant and visionary co-cinematographer, to its pugnacious triumvirate of stars, Vincent Cassel, Monica Bellucci and Albert Dupontel. As such, while Noé's status as writer-director is undoubtedly an extraordinary case, his applied cinephilia channels some of the fiercest, most aesthetically decisive film work emerging in the early twenty-first century. From our principal vantage point of France, roaming abroad to the USA and UK, we'll also see how *Irreversible* has been subject to some of the most polarizing critical attention in recent years: utterly contradictory at times, usually intensely ambivalent; some of *Irreversible*'s sternest reviewers even took on the role of media police. Although it will doubtless be forever controversial, never an easy sell, *Irreversible* does emerge, on many fronts, as a landmark production of sorts, a limit case or outlier contemporary French film, a lightning rod for debates inherent in expectations about cinema's acceptable conduct – or otherwise. I'm confident that *Irreversible* will still be screened for decades to come, and with some admittedly initial reluctance I am pleased to have returned to consider it at length here.

On a logistical note, in the text that follows, all translations from French materials, unless otherwise noted, are my own. Film titles are in general given in their English version, where those films gained international distribution. All screen captures are taken from the 2003 Lions Gate *Irreversible* DVD. Although no material is directly reproduced here, interested readers of this book are encouraged to seek out my more general survey, *Brutal Intimacy: Analyzing Contemporary French Cinema*, which expands some of the arguments I will make in this monograph. Hopefully here and there my writing does justice to the wonderfully sprawling film ecosystem that makes contemporary French cinema so rewarding.

Segmentation

Irreversible unfolds in reverse chronological order: a title sequence followed by 13 segments of temporally distinct, inverted diegetic events. Each of these segments is conveyed in a long take, either from an actual continuous sequence shot or else a series of fragmentary takes digitally composited to appear to be one whole. Sometimes the gap between segments is obvious, punctuated by flourishes like cinematography arcs through space; sometimes the events appear deceptively consecutive, as in the bridge between segments 6 and 7. The film is thereby structured as follows here, and I number the segments for ease of reference in the analyses that come later. *Irreversible*'s stylistic execution is frequently invasive, but where aesthetic and aural devices are especially vital to configuring the events conveyed, those technical features are noted alongside plot points.

> *Titles*: Under sounds of rumbling wind, the credits scroll downwards: top to bottom, with only last names listed. Strategic letters (E, K, N, R) are flipped backwards. By the 'Costumes' credits, the words begin to reorient diagonally. The images then spin, minor-key electronic tones play, and after a rotating preview glimpse of segment 1, the major credits, as single words, flash flicker on-screen, alternating white, red and orange colours, as a drum beats.

1. A flying mobile camera spins and glides through space, discovering a brick tenement building, at the base of which blue police lights flash. Minor-key string tones are replaced by an intermittent electronic whine. Continuing to whirl, the camera enters a small apartment, where it encounters a naked man (Philippe Nahon) sitting on a bed. To a younger male companion, he declares, 'You know what? Time destroys everything'. He then confesses to having slept with his daughter, suggesting that he is the Butcher protagonist (although he is not credited as such) of Noé's previous *Carne* (1991) and *I Stand Alone* (1998).

The growing noise of sirens outside prompts disparaging remarks about The Rectum nightclub beneath the men. From there an overhead shot now shows Marcus (Vincent Cassel) being wheeled out of The Rectum unconscious on a stretcher. As he leaves, homophobic insults are yelled; one male voice sneers, 'Like Alex, I hope it bled, I hope it hurt'. Next, Pierre (Albert Dupontel) is ushered out in handcuffs. The two men, with police, are driven off in an ambulance.

2. After traversing more space, a series of increasingly loud bass tones accompany the camera's descent into The Rectum, where many assorted gay sex acts, some sadomasochistic, are glimpsed. An enraged Marcus, barely restrained by Pierre behind him, heads in, try-ing to find a man called Le Tenia (Jo Prestia). Marcus begins to attack patrons in search of information, one of whom retaliates by breaking his arm and preparing to rape him. Pierre intervenes, beating this assailant to death with a fire extinguisher. Le Tenia watches the murder.

3. In night-time Paris, Marcus drives Pierre in a taxi in search of The Rectum. They enter a café to interrogate locals about its location, with-out success. Marcus quizzes male prostitutes below an underpass, one of whom suggests that The Rectum is nearby. When Pierre pleads that they should go and visit Alex in hospital, Marcus smashes the car's windshield with a crowbar.

4. Marcus and Pierre are in the same taxi, now occupied by an Asian driver. Marcus asks to be taken to The Rectum – 'A club for fags, understand?' As the driver becomes confused, Marcus gets incensed, making racist insults and eventually spraying the cabbie with his own container of tear gas. Marcus then steals the taxi as Pierre begs him to calm down.

5. Accompanied by Mourad (Mourad) and Layde (Hellal), who expect payment, Marcus and Pierre walk down an alley. Directed by the men, they eventually seize upon Concha (Jaramillo), a transgendered prosti-tute whom Marcus threatens, who turns out to be the Guillermo Nuñez they have been looking for. She tells them that Le Tenia can be found at The Rectum. Marcus and Pierre drive off in the taxi.

6. Near a crime scene, Pierre denies in a police interview that he is under the influence. He rejoins Marcus; both men seem catatonic with shock. They are approached by Mourad and Layde, two local thugs, who suggest that vigilante justice, with their paid help, will be better than waiting for the ineffectual police. They reveal that they have previously caught and punished a local rapist, and also that they know that a purse with an ID card inside was found at this new crime. The name on the card is Guillermo Nuñez.

7. Leaving a party, beside a glowing underpass sign, Marcus sees a severely injured Alex (Monica Bellucci) being stretchered away, as reverberating heartbeats erupt on the soundtrack. He clings to her prone body, sobbing with grief. The camera swirls through space again as Marcus's cries continue.

8. Alex, in a form-fitting evening dress, exits an apartment building. She fails to hail a taxi. A prostitute leaning on a lamp post advises her to take the subway tunnel rather than cross the busy road: 'It's much safer'. Alex descends into the red pedestrian underpass, where she finds Le Tenia accosting, then beating, Concha, who runs off. Le Tenia turns his attention to Alex, and attacks her. In a static long take, Le Tenia pins Alex to the ground, anally raping her, then pounds her head against the pavement until she is unconscious. A passer-by, visible in extreme long shot, at one point sees the unfolding crime, but does not intervene.

9. Marcus and Pierre are upstairs at a party. Marcus jokes that Pierre has a problem with his sexuality because he has been alone for three years; Pierre calls him pathetic and repeatedly suggests that they should return to Alex, who is alone. Marcus snorts a line of cocaine and kisses two women. Marcus and Pierre then go downstairs, where a DJ is in session playing dance music before a throng of partygoers. Outside on a back terrace, Alex dances intimately with two other women; Pierre looks on. Marcus reappears, quipping, 'Look how gorgeous she is!' He then says that his name is Vincent, before correcting himself: 'It's

really Marcus'. In contrast with the manic Marcus, Pierre remains calm yet visibly uncomfortable. After confiding to another friend that 'today's a special day', Alex leaves the party, irritated by Marcus's need to take drugs to enjoy himself, when ordinarily he can be 'so tender'. Pierre tells Alex that he loves to look at her, referring to their past together, and warns her not to leave as it isn't safe. She departs anyway, asking him to take care of Marcus.

10. Marcus, Alex and Pierre descend in a Metro elevator to the Buttes Chaumont platform. She describes a book she is reading that argues that everything is predestined. Pierre discusses the intimacies of when he and Alex were lovers, referring to Marcus, his successor, as a social reject with a primate's head. On board the train, Marcus, his arm round Alex's neck, discusses his sex life with his quasi-rival; Pierre admits that he was too cerebral to satisfy Alex sexually. Pierre gives Marcus a pill, which he swallows.

11. Early evening: waking up gradually, Marcus and Alex are naked in bed together, her body on top of his. They converse: Alex tells him that her period is late, and that she had a dream, set in a tunnel, 'all red', which broke in two. Marcus responds that his arm has gone to sleep, and that he has to be nice to Pierre at the party they are going to, as he stole her from him. The couple dance to a record, kiss at length and then return briefly to bed, before Marcus leaves to buy wine. Before he goes, he kisses Alex through and around a shower curtain. Alone, Alex takes a pregnancy test, which, based on her delighted laughter, then pensive expression, is positive.

12. Beethoven's Seventh Symphony accompanies a zoetropic camera whirl, eventually turning into a track into and up over Alex, in a floral dress, hand on belly, sitting in her apartment asleep under a poster of *2001: A Space Odyssey* (1968).

13. As the music continues, Alex is seen in a park reading *An Experiment in Time* (1927) by J.W. Dunne. This, *Irreversible*'s only daytime scene, is resplendent with rich primary colours. Alex is shown from above as

the camera retreats upwards. The camera begins to spin, framed initially from above over a sprinkler, then trained on the sky. The image and sound become abstract: flickers of white and a pulsing roar, under which are glimpses of rotating constellations in space. A final caption reads, 'Time Destroys All Things'.

✖ Introduction

It is a sultry Thursday night, a little before midnight, on 22 May 2002
at the Grand Théâtre Lumière, main venue for the 55th annual Cannes
Film Festival. Amidst pageantry and pomp, the world premiere of Gaspar
Noé's film *Irreversible* is about to take place. The capacity of the enormous
screening room here can reach 2,400, and the customary Cannes spectacle
builds as a throng of invited guests arrive on the famous red carpet. Running
the gauntlet of energetic journalists, celebrity attendees are pounced on
as cordoned-off crowds of onlookers cheer. Younger notables from the
French film industry are also present: Mathieu Kassovitz, among others,
signs autographs and says in a quick interview that Cannes is a great place
to present challenging films, such as the one scheduled to play tonight.
Moments later, *Irreversible*'s cast and director appear. Noé himself, asked
if he is nervous, smiles wanly and admits only to being excited. Monica
Bellucci, in a gleaming black evening gown highlighted by popping
flashbulbs, confides to another interviewer that she is overwhelmed at the
scale of the reception, but that she expects audiences to be divided by what
they are about to see. Vincent Cassel, bearded and longhaired alongside her,
his collar unbuttoned under a sleek black suit, shares a joke with Noé before
standing to pose for yet more photographs on the steps in front of the
theatre doors. By the time Albert Dupontel, *Irreversible*'s other headlined
star, joins the trio, the white camera flashes around them are almost
continuous, a stroboscopic pulsing of light; the surging crowds nearby are
by now shouting desperately, shrieking even, to try to get someone, anyone,
to look their way: '*Monica, Monica! Vincent!*' On the official Cannes Festival
commentary track, broadcasting live on national French television (and

subsequently archived on the festival's website) one droll journalist quips to his colleague: 'This is the music of *Irreversible*'.

Irreversible's actual screening intensified this prelude to the main attraction. Before the film was half-finished, approximately 250 of the festival crowd had already left the theatre, many of them exiting noisily, doing their best to disrupt proceedings. Booing and catcalls periodically broke out inside the screening room, the angriest cries during the film's most violent sequences, especially the rape in segment 8. This is a pattern that would be repeated at successive festival screenings, although *Irreversible's* Saturday rerun, in the early hours of the morning, did culminate in a five-minute standing ovation. According to in-the-field BBC reporting, moreover, among the Thursday/Friday-night-premiere 10% walkout contingent, 20 people actually required emergency first aid, with fire wardens called upon to administer oxygen to overcome viewers who had either passed out or else suffered from severe nausea. One of the emergency workers present, Gérard Courtel, captain of regional fire services, who had initially stepped inside the theatre to watch, was quoted as saying: 'In my 25 years in my job I've never seen this at the Cannes festival.... The scenes in this film are unbearable, even for us professionals' (Anon. BBC, 2002). International news reporters, alerted to the tensions, took every opportunity to gather sound bites from the unhappy walkouts. Todd Rubenstein, an entertainment lawyer from Los Angeles, was interviewed by Reuters and declared that Noé's film was, in a line widely reproduced among accounts of the festival, 'Disturbing and incredibly violent – not just the graphic violence and the language but the camerawork made my stomach churn' (Reuters, 2002). Even select celebrities were polled to gather negative press: Pascal Gentil, a French Olympic medallist for Tae Kwon Do (hence implicitly a tough personality), complained: 'When I see a film like that I find it hard to imagine what people must have inside them that they are able to make such a thing – I found it sickening' (Reuters, 2002).

Tempers continued to rise, and momentum against *Irreversible* grew. By the time of the film's official press conference – itself something of an

arena showcase: the room packed with scores of journalists perched on stadium seating, many of them on the edge of those seats, leaning forwards down towards the panellists below – Cassel tried to downplay the growing controversy, suggesting that Cannes required an annual furore, and Noé's film was simply being ushered into this preordained role. 'We have done nothing to create scandal', Cassel argued, making sweeping hand gestures, cocking his head in disbelief at the crowd above him (Reuters, 2002). But the tone of inquiry nonetheless grew restless, then hostile. Noé was charged with complicity towards *Irreversible*'s rape and violence; Cassel became visibly angry at accusations about Noé's allegedly salacious materials; Dupontel moved to deflate tensions by steering the conversation towards a more neutral discussion of camerawork and style. Shortly after, on Sunday, 26 May, Patrick Frater reported for *Screen Daily* that rumours were sweeping Cannes about *Irreversible*'s actual selection process – that the film's inclusion had apparently been protested vehemently beforehand by two of the festival's (unnamed) jurors, and that only the personal intervention of Thierry Frémaux, the newly installed artistic director, who threatened resignation if Noé's film was pulled, had secured its eventual place in Cannes's competition at all (Frater, 2002). Unsurprisingly, *Irreversible* went on to win no awards. The same day, a BBC Sunday headline proclaimed, 'Cannes Film Sickens Audience', a sentiment widely adopted. Judgement, it seems, had been reached about Noé and *Irreversible*.

Revisiting the occasion of *Irreversible*'s notorious Cannes debut sets the stage for what will follow, the origin point of its controversial status. This is a film to induce backlash, to repel but also inspire, to rally some in its favour just as others counter-attack. A film premiering at Cannes is an institutionally privileged thing, an emblematic work of some kind; but clearly this is a station that can also leave you vulnerable – a bright spotlight of exposure turning into the prying beam of zealous interrogators. Many attending film-makers passing through Cannes, Noé included, have remarked on the festival's double-edged nature. Cannes is a site of great cultural prestige – receiving an invitation is a sign of a career either on the

rise or at its zenith – but it is also a place where restless film crowds go to cause trouble, to cheer what they like and jeer the works of their enemies. The first stage of *Irreversible*'s controversial arrival in the world, we might reflect, came then from its negotiation of the exhibition process: a flashpoint on the film festival circuit, headed by Cannes since 1946, which serves as a configuring – and combustible – first juncture into film culture itself, creating in turn a nascent canon, sometimes with attending birth pains. While *Irreversible*'s debut was inarguably, perhaps unavoidably, contentious, it puts Noé's film in the context of a long ancestry of films whose repute began like this, propelled into notoriety rapidly, instigating battles for their reputation and worth. One immediate peer to *Irreversible* might be *L'Avventura*'s 15 May 1960 Cannes premiere, a film angrily denounced by the majority of those present as vapid and unbearable, only for its fortunes to revive until its subsequent acclaim as Michelangelo Antonioni's crowning work, a decisive modernist piece of European art cinema. For a book in a series about controversies – films whose appearances have inspired hatred and perhaps also its counterpart – a good point of departure, then, is to begin with the idea that contestation and dispute do frequently greet films that somehow manage to linger, to last, to withstand scrutiny and end up valuable to successive audiences as time passes. Controversy might indeed prove to be the antithesis of ephemerality, that true opponent of the ambitious film-maker.

This book is an analytical biography of *Irreversible*, and the pages that follow will both embrace, and deconstruct, the idea that controversy is inherent to understanding Noé's work. On one front, controversy means disputatious, something that creates altercations or quarrels. From this idea comes a central line of reasoning in this book – that *Irreversible* is a film riven by, defined by, inversions. Taking this cue, I will by necessity attend to *Irreversible*'s reversals, of forms turned around and rendered backward or inside out, a major configuring process through which we as viewers are inexorably estranged from what is (cinematically) familiar. (Something architecturally commensurate with Noé's tactics might be the

Centre Pompidou, designed by Renzo Piano, an iconic high art enclosure built for the Parisian masses with its innards where its skin should be, the internal made external.) For a text saturated with ironies, from the bleakly witty to the biting or horrifying, one of the most important arises from the film's actual title. In Noé's model, *Irreversible* refers not to the sense that things cannot be inverted (they palpably and inevitably will be), but that this reversal process itself, propelled past a certain diegetic tipping point, renders the world dangerously but compellingly incoherent, threatening and ineffaceable, rife with challenge all the more profound for being frequently either hard or impossible to understand. *Irreversible*'s reversals disrupt and attenuate, and conceptually this inversion (anti-)logic subtends the entire diegetic world, plus the audience apprehending it, so as to induce fundamental entropy, a destabilization of its fabric, to make exposure to its materials traumatic. From here, another major point to underline, right from the start, is that *Irreversible* and its shaping film-maker, despite their reputation among detractors as hysterical extremists, are absolutely systematic, ruthlessly controlled.

This account of *Irreversible*, then, will retain decisively this notion of inversions, the framework of trade norms, professional protocols and creative incursions which Noé reinvented by turning them on their head. What emerges, in sum, derives from *Irreversible*'s suite of bravura, sustained ruptures: in its fiscal protocols and production mandates; its highly subversive use of performance and iconic screen personalities; its measured, even elegant, yet abrasively disconcerting cinematic style; its immersive but discomfiting coercion of the viewer; its threatening overhaul of Paris's traditional on-screen portraiture as an idyllic centre of leisure and culture; its position as iconoclastic, yet also central to certain large-scale shifts in production practices in France during the late 1990s; its combative relationship with classical style and art cinema alike; its citations of pulp cultural forms that are bewilderingly infused with avant-garde and intellectual motifs. Top-to-bottom, through and through, *Irreversible* is a composite of strategic overhauls, about-faces and turnarounds. From

this dynamic, in fact, comes *Irreversible*'s extraordinary capacity to arouse audiences ever since that fateful 2002 night in Cannes, a capacity that will likely never wane.

My own analytical ideology will also itself be controversial, a reversal of a reversal, in that for all its machinations I treat *Irreversible* throughout as a brilliantly creative engagement, a productive text bursting with artistic innovations, a valuable and enduring piece of work, at times a study of beauty as well as depravity. Despite its partisan reputation as a purely disagreeable sui generis film, I also find *Irreversible* to be a profoundly, essentially French text, a loadbearing production at the heart of one of the world's finest film production centres, a representative achievement from what is arguably our only true contemporary film ecosystem. As such, to consider the gestation and emergence of *Irreversible*, this book moves in its methodology from the broad to the specific. We begin in the shaping landscape of French cinema in the 1990s, surveying its uncertain and often difficult forward progress into the new millennium, and how *Irreversible* manifests as an important case study, reflecting some of the innovations that reinvigorated French film during this period, while also proving antagonistic to other long-standing craft norms. From here I next pursue the idea of Noé himself, *Irreversible* in hand, as a rational agent in clear conversation with a cohort of similarly galvanized, restless peers. These creative malcontents, as I will show, became jointly responsible for an extraordinary group project, a *cinéma du corps*, or cinema of the body, of artfully contrived pieces of counter-cinema, hinging upon treatments of the body, and corporeal appetites, in a harshly stylized diegetic world stripped of social and personal safeguards. Next our address becomes more specific and personal-professional, contemplating both Noé's fascinating career course, the range of film trade encounters that led to *Irreversible*; then unpacking the film's essential textual components, from its wealth of narrative and stylistic idiosyncrasies, to its unusual deployment of those French stars showcased at Cannes; to the uneven contours of its critical reception in France and beyond. Our last focal point might be the most

dissenting, in that the book concludes on *Irreversible*'s neglected final segments, during which extraordinary manifestations of profound romantic love and feminine corporeal utopia configure Noé's beatific climactic address to the viewer. Across this analytical spectrum, we can already begin to conceive of *Irreversible*'s lasting significance to French and world cinema: in its densely rendered ability to countermand and disorganize, but also to recreate and reinvent. While *Irreversible* might undeniably be controversial in terms of the effects it has on viewers, in its constitution Noé's work is also devastatingly inventive and catalytic, a decisive contribution to contemporary film-making.

✕ PART 1

CIVILIZATION AND ITS
DISCONTENTS: *IRREVERSIBLE*
IN THE FRENCH FILM
ECOSYSTEM

A good place to start with *Irreversible* is its country of origin: France. For as a nation-state, contemporary France expends tremendous resources in supporting an indigenous ecosystem of cinema, one of the most dynamic collective modes of film production yet devised, within which Gaspar Noé is a high-profile participant (Palmer, 2011, pp. 1–13). This interrelated system of ideology and practice, an enviably rich media landscape, from the outset establishes *Irreversible* as a fascinating outlier case. But crucial nonetheless to *Irreversible*'s configuration are the shaping contexts, the generative mechanisms in contemporary French cinema from which Noé's film, creatively embattled yet also engaged on many fronts, came. So what was taking place in France's cinema industry to affect *Irreversible*'s genesis, specifically around 2001–2002, as French film evolved, rapidly, from its early 1990s nadir to a more dynamic state? Or, in broader terms: What was it that was making French cinema French, creating the currents buffeting Noé, affecting the creation of such a bizarrely confrontational project?

First, there is the big picture. Emanating from the activities of the State-monitored Centre National de la Cinématographie (CNC), France's mission for its film and media industry is clear. The objectives are these: to sustain an innovative national production output underwritten in part by taxation revenues and national grants (the CNC disbursed 55 million euros to film producers and distributors in 2002 alone); to maintain a network of film-making schools to instantiate cineliteracy and advanced technical proficiency among France's emerging film-makers; to create an annual slate of products suitable for export via the French Government's array of international outreach cultural divisions; to facilitate the passage of younger directors into the film industry quickly; to encourage a degree of diversity (in recent times, especially focused on gender parity) among its film-makers; and, above all, to produce texts that proclaim their 'Frenchness' in reasonably regulated sociopolitically and artistically acceptable terms, at times admitting avant-gardists. From this cluster of ideals, an overriding mantra, we can see already how Noé's relationship with the norms and institutions of French cinema are fraught. *Irreversible* emerges, here and elsewhere, as a profoundly

ambivalent work, a problem text resisting easy classification, a film kin
to and informed by certain of its peers, utterly opposed to others, very
recognizably French (chosen as a headlining act at Cannes), yet defiantly
resistant to many values of this uniquely variegated national cinema.

How does contemporary French cinema work, and in what ways
is *Irreversible* an institutionally rogue, or otherwise, production? In its
contemporary phase, a network of fixtures now informs France's yearly film
production. Like most global film industries, France's cinema is primarily
defined against the incursions of North America, the ubiquitous onslaught
of Hollywood product. The famous designation of 'Cultural Exception'
overrides here, a term which emerged in 1993 as part of the Uruguay
Round of negotiations during the General Agreement on Tariffs and Trade
(GATT), a category cited vehemently since then by France as a rationale
for excluding culture from free market trade arrangements. French cinema
culture, therefore, is a vital linchpin of French national identity, a key part
of how France perceives its values to be disseminated globally, instantiated
as a culturally progressive nation on screens around the world. In Michel
Marie's summary, 'French cinema constitutes an exception in the world
by its resistance to the Hollywood machine, often considered unstoppable'
(2009, p. 9).

Maintaining France's film ecosystem requires constant scrutiny.
Culminating in a detailed dossier produced each year, the CNC assesses
all aspects of French film and media production, with particular emphasis
upon the market share that indigenous product secures versus the tide of
American imports. Higher profile, the Cannes Film Festival, since 1946
the leading such global event, is run annually in part to showcase France's
status as a major epicentre of world film, a symbolic host nation for all that
world film has to offer, with favourable terms usually given to screening the
best and brightest of French film-making; in 2002, *Irreversible* was one such
invited guest, of course, where all the trouble began. Alongside this, each
year since 1976, the César Awards – France's Oscars – are awarded to the
best French films, as voted by active members of the Académie des arts et

techniques du cinéma (*Irreversible* received no nominations); the César is just one of a suite of annual prizes that celebrate France's cinema. In terms of production protocols, Governmental legislation also protects film, the jewel in the crown of France's media industries, by assuring investment from national television networks and pay-per-view enterprises like Canal+. In 2002, for instance, French terrestrial television channels spent a combined 108 million euros on 103 productions, a sum that had doubled in less than a decade (Creton, 2005, p. 79). Beyond France's borders, agencies such as UniFrance support the global distribution of French films, whose international circulation is second only to Hollywood's, in part buoyed by a suite of specialist French film festivals held each year in major overseas territories like North America. In sum, France works tirelessly to safeguard its cinema, while promoting global recognition of its film wares as they travel abroad.

Zooming in slightly, French cinema can be broken down into its constituent parts, which again situate *Irreversible* as both iconically French yet also in certain ways a fringe project. In the first and arguably primary instance, popular cinema remains the backbone of the French film industry, anchoring its local appeal. Unlike the fixation on box office grosses in most world markets, France prefers to quantify popularity more objectively through attendance figures: the upper echelon of a *millionnaire* category, those films that annually attract a million or more paying customers, which are then officially recognized as leading success stories (Palmer, 2012a, pp. 201–207). In terms of materials, this popular *millionnaire* sector is historically oriented to popular genres such as the comedy and the policier crime thriller, added to which more recently is the action spectacular. This latter format derived from the influential business model of Luc Besson and Pierre-Ange le Pogam's EuropaCorp, a venture designed essentially to outdo Hollywood at its own game, started in 2000. Discussing the comedy genre in particular, Anne Jackel states a case that could really apply to the whole of France's robust film mainstream: which is 'snubbed by cinephiles, neglected by historians and despised or ignored by film

critics' (2013, p. 243). As Charlie Michael presciently notes, however, as the 1990s gave way to the 2000s, a deep-seated new direction within the French film industry embraced what some critics called a kind of 'post-national' or transnational blockbuster model (2005, p. 55–74). This form of production – initiated by Besson's *The Fifth Element* (1997), followed by copycats like *Crimson Rivers* (*Les Rivières pourpres*, 2000), *Vidocq* (2001), *Kiss of the Dragon* (2001) and *Brotherhood of the Wolf* (*Le Pacte des loups*, 2001), gravitating from there to a franchise mentality based upon series like EuropaCorp's all-conquering *Taxi* and *Taken* films – pursued a sturdily (and defiantly) pro-international model, which, as Isabelle Vanderschelden notes, threatens to make 'the "French Cultural Exception" debate appear obsolete and irrelevant' (2008, p. 102). This new ultra-commercialist approach was in part a legacy of Jack Lang's two stints as French Minister of Culture (1981–1986; 1988–1993); his 'Lang Plan' sought to reverse the decline of French cinema by encouraging private investment into media manufacture: deregulating state television channels (TF1 and M6), founding Canal+ as France's inaugural pay-per-view cable outfit and establishing tax shelters for producers. On-screen, subsequently, a French commercial aesthetic was highly visible by the late 1990s, manifesting through reliable ingredients: charismatic marquee stars, global templates (such as Asian popular genre components or Hollywood action film editing principles), flashy production values, escalating budgets and, in sum, materials that no longer seemed to many to be especially French at all. As Michael concludes, such non-traditional yet lucrative French blockbusters 'reflect the complex ideological give-and-take of an industry searching for different ways to wed nationalist sentiments to commercial forms of entertainment' (2005, p. 71). *Irreversible*, as we will discover, shows that Noé was also very much attuned to these new internationalist templates, and especially the commercial and creative value of internationally recognized stars.

More traditional trade practices elsewhere nurture France's film ecosystem, again proximate to Noé's emergence. One vital source of

film-making in France, frequently overlooked, is its film school circuit, in
which advanced pedagogy affects both emergent and established French
film-makers – including Noé himself, for all his posturing as an iconoclast.
There are two major, illustrious institutions here. The first is La Fémis
(L'École Nationale Supérieure des Métiers de l'Image et du Son), the
leading and highly competitive pedagogical centre, which in 1986 took the
place of L'Institut des Hautes Études Cinématographiques (IDHEC; begun
in 1944 after the Liberation under the auspices of Marcel L'Herbier) as the
State's main centre of film instruction. La Fémis is designed to foster applied
cinephilia, in which a sustained critical study of historical and contemporary
films informs superior practical experiences; its recent graduates, some
of whose projects are as combative as Noé's, include Jean Paul Civeyrac,
Marina de Van, Noémie Lvovsky and François Ozon; many of its alumni
return to teach advanced seminars, reinforcing the school's artistic ambitions
(Palmer, 2011, pp. 195–208). Related to La Fémis, but more of a pure
technical trade school, is the École Nationale Supérieure Louis-Lumière, set
up in 1926 under the patronage of Louis Lumière and Léon Gaumont. This
school's more commercialist ideology was confirmed in July 2012 when its
base of operations moved to Besson's new Cité du Cinéma at Saint-Denis in
Paris, an attempt to create an all-in-one centre of film operations, something
like a classical Hollywood studio throwback. Many of Louis-Lumière's
graduates – including Noé in 1982 – move quite rapidly into the profession,
promoted on its credentials, often with a completed student sample of work
in hand, underlining how much France conflates advanced film instruction
with a healthy film trade, expecting its film-makers to be good students and,
later, good teachers too. So ingrained is this principle that it even extends
beyond live action film-making, notably to France's resurgent animation
sub-industry, derived largely from schools like Gobelins and L'École
Georges Méliès, which collectively undergird the extent to which, according
to Richard Neupert's recent study, 'animation has become economically
important, aesthetically vibrant, and culturally crucial to France's persistently
impressive national cinema' (2011, p. 169).

Noé's place within this dynamic film school system – a role to which he has returned, as we will see later – also confirms the extent to which the French film ecosystem thrives on supporting newcomers, getting emergent professionals into the business quickly and, more generally, providing forums for blossoming artists bent on creating advanced works of film art. Since the historical concerns of the early 1950s, indeed, when internal and external perceptions agreed that its film business was aging badly, France has systematically instantiated long-term policies to invigorate its film profession, rallying around the putative 'quality' of French cinema. As Colin Burnett suggests, after World War II these quality debates hinged mainly upon the CNC's commitment to supporting riskier, non-commercial fare, built on the ideal that a film author, a creative auteur, would inevitably be at the heart of such ventures. While debates about exactly what such State-sanctioned French quality cinema was and should be – François Truffaut famously attacked it while others, like André Bazin and Jean-Pierre Barrot, hailed its potential merits – it is to auteur-derived individualist French cinema that the CNC's audits and grant-giving bodies turned, and have been nurturing ever since. As Burnett and economic historian Frédéric Gimello-Mesplomb both conclude, the key date was 11 March 1957, when the French State made law a decree recognising the status of 'author' for audio-visual texts like films. The stage was henceforward set for France's cinema accommodating a population of idiosyncratic practitioners of film, convinced that the Seventh Art was a métier suited to the artistic aspirations of France herself (Burnett, 2013, p. 143; Gimello-Mesplomb, 2003, p. 101). The legacy of the New Wave generation's rebellion lingers, and Noé, once again, is both descendent of, and uneasy compatriot to, such fundamental currents in the post-war French film profession.

From this post-war period onwards, the French cinema ecosystem has built upon, and consolidated around, the ideal of the young maverick auteur film-maker, a persona modeled by Noé. Represented by the New Wave of the late 1950s and early 1960s – itself best thought of in part as a rhetorical platform, a wave of pro-youth propaganda – France has encouraged the

rapid emergence of younger film-makers, building fledgling reputations through short film experiments, calling cards to be used to solicit interest from producers and grant-awarding bodies. France's is indeed a young and dynamic film industry. In part boosted by the CNC's *avances sur recettes* (advances on receipts) scheme, an up-front grant which, since the New Wave era, has disproportionately favored artistically adventurous first- and second-time directors' projects, the annual slate of French production is constantly infused by newcomers. Although Noé did not get an *avance sur recettes* grant for *Irreversible*, many peers around him did: in 1997, 46 debut feature films were made, or 37% of France's total productions; the number had risen to 67, or 41%, by 2002 (Palmer, 2011, pp. 15–21). Noé, who turned 39 when completing *Irreversible*, his second feature, was thus something of a late starter in this context, but his rosta of six completed short films by 2002, as well as music videos and assorted production credits (as assistant director, cinematographer, camera operator and sound recordist) for other directors, makes him a representative case of working his way up through the French industrial ranks systematically, his ambition matching opportunities received.

So what should a good citizen of the contemporary French film State do? What expectations are there for their work, and how should they comport themselves professionally? As befits a nation of film students and professors, the contemporary French film-maker must first of all showcase cineliterate craft in their work, and, above all, be able to situate their work artistically and historically in interview. Far more so than the United Kingdom and the United States, film criticism in France thrives, and the French director concomitantly has to raise their profile – or in Noé's case, defend their transgressions – through densely explicative professional conversations on festival panels, in the columns of newspapers, film and culture magazines, and via online forums. *Irreversible*, as we will see, alongside twenty-first century French causes célèbres like *Persepolis* (2007), *Bienvenue chez les Ch'tis* (2008) and *Intouchables* (2011), arguably generated the most column inches and cultural discussion of any contemporary French

film text. While pre-production and production are typically considered the most labour-intensive phases of a film-maker's work, in France this reception phase can often be one of the most demanding periods of activity. In sum, as I will consider later, Noé as a representative French film-maker must be able to engage with critics, offer a systematic aesthetic rationale for his work, cite stylistic precursors as artistic stimuli, and make a case, resting on a relatively small body of work, for himself as a sophisticated, perhaps even precocious auteur, much as Godard, Truffaut and the New Wave generation had made self-promotion an industry norm after the 1960s.

To get more proximate to our text at hand: what was the exact situation of the French film business in 2002, as *Irreversible* entered the film festival circuit and general distribution and reception? Overall, France's cinema industry was resurgent: 184.5 million film tickets were sold in 2002, of which 64.6 million were for French productions: both of these figures were very slightly down on 2001, offset by increased average admission prices, 5.44 euros rising to 5.57 euros. (*Irreversible* sold 553,415 tickets in France and more than a million across Europe, making it, perhaps surprisingly, a respectable hit.) In its annual report, indeed, the CNC trumpeted that the new millennium was ushering in a new era of French cinematic growth, that 'among the last fifteen years, 2001 and 2002 have been the best years for French film…market share is being maintained at a comfortable level in regards to preceding years' (CNC, 2002b, p. 1). General production data underscore France's gains: from only 89 films produced in 1994, something of a historical low point, France managed a more robust 163 in 2002; a figure of about 200 has since 2009 or so become an annual target around which the field has stabilized (CNC, 'La Production cinématographique en 2002', p. 5; Palmer, 2011, pp. 7–10). France has long had a reputation as a low, even microbudget alternative to Hollywood, but production costs in fact rose steadily during this period. From an average of 3.4 million euros in 1993, the total average French production cost went up to 4.4 million euros in 2002; by 2008, prior to the world economic crisis, the figure had reached 6.4 million euros. Foreign investment – and France has

since the 1950s consistently sought European partners to shore up its media industries – concomitantly covered just under a quarter of these production expenses. Evidence for the diversity of French film budgets, from the microscopic to the grandiose, was increasingly apparent by 2002. That year's cheapest film was François Fourcou's documentary *La Bataille de Bordeaux* (2002), made for just 200,000 euros, while the most costly was Jan Kounen's *Blueberry* (2002), a CGI-intensive *bande-dessinée* (graphic novel) adaptation, whose bill eventually ran to 36.13 million euros.

Underlying this industrial buoyancy and gradual escalation of budgets, however, was a divisive fiscal tendency that was by 2002 starting to fray nerves within France's film trade. In this frame, *Irreversible* played an unexpected part. The drama centred upon the perceived collapse of France's historically traditional mid-range budgeted productions, the so-called *cinéma du milieu*. This celebrated French business model – associated with film-makers from Jean Renoir, to Truffaut, Jacques Becker and Alain Resnais – was, in an acute irony, one that *Irreversible* actually adopted, hence becoming, in retrospect, something of a retrograde or classically defined French production model. Rumblings about the perceived decline of these mid-range French productions were starting to appear in industry journals like *Le Film français* (the French *Variety*) by the early 2000s, but tensions erupted at the 2007 César Awards, when Pascale Ferran, graduate of IDHEC and director of *Lady Chatterley* (2006), which had just won five prizes, during her acceptance speech attacked the 'recent fracture' in French cinema, in which either tiny or large budgets were becoming a new norm, eliminating the *films du milieu* (costing about 3–8 million euros) which had always supported France's best film-makers.

The dissidents rallied; the perceived attack on France's *cinéma du milieu* began to attract more attention. After the 2007 Césars, Ferran convened a Club des 13 of film-makers, producers, distributors and exhibitors, industry professionals all, whose published findings, *Le Milieu n'est plus un pont mais une faille* (*The Middle is no longer a bridge but a faultline*), further argued that this trend was threatening the security of

French cinema itself. As Vanderschelden points out, when articulated by the Club des 13 and discussed widely thereafter, the *cinéma du milieu* is not just a fiscal term but one of idealized Frenchness: a 'quality trademark for French cinema, namely a creative and ambitious approach to making films with potential popular appeal...an artisanal, craftsman-like relationship to film-making which links *films du milieu* with art cinema' (2009, p. 245). Film-makers allegedly confronted by this vanishing *cinéma du milieu* in the Club des 13 report, therefore icons of its prestige, were figures like Xavier Beauvois, Claire Denis, Arnaud Desplechin, Bertrand Tavernier and André Téchiné (Club des 13, 2008, pp. 66–68). The Club des 13 offered a series of proposals to rectify the situation, ranging from raising France's slate of film subsidies and adding to the CNC's dominion, promoting the input of creative film producers rather than commercialist television executives and valorising (with grants) the writing process rather than the distribution or exhibition stages. In sum, to many observers, on a financial level the French film industry was once again felt to be lurching towards crisis, losing its edge.

Fiscally and creatively the *Irreversible* case offers a clear rejoinder to the Club des 13, in part demonstrating how Noé, an assertive newcomer far from being an industry darling like Ferran, was able not only to secure ground in the *cinéma du milieu* but also to use its assets for very non-traditional, even experimental purposes. The impact of *Irreversible*, not without irony, can indeed be taken as a symptom of the relative creative verve and vigour of French cinema in 2002. For alongside the Club's sounding of alarm bells – you either had to cope with a pittance for your budget or sell out and make banal commercial fare! – one of its report's main points of attack was institutional: that conservative television alliances were undermining those film-makers *du milieu* driven to try riskier artistic projects. Even beyond the Club's findings, the same prognosis, that corporatist television jurisdictions would inevitably stunt cinematic art, or at least prevent the able-minded from taking artistic gambles, had become something of a truism in the early twenty-first century (Frodon

et al., 2004). Jonathan Buchsbaum, responding to Jean-Michel Frodon, suggests that this tone of diagnosis confidently proclaimed 'television to be a maleficent influence on film' (2005, p. 48). In contradicting such deep-seated assumptions, yet again Noé and *Irreversible* enter into the heart of debates about contemporary French cinema in general, but even in industrial terms they provide unexpected conclusions, throwing a spanner in the works. *Irreversible*'s budget was 4.61 million euros, making it indeed a good instance of the putative *film du milieu*, just above the 2002 national average and certainly a representative case for the industry at large: it was 100% French funded and crucially got advances from both of France's main pay-per-view television channels, Canal+ and TPS, the latter through its (ultimately short-lived) TPS Cinéma subsidiary. During and after his post-production, Noé would frequently refer to *Irreversible* as a weird hybrid underground big budget movie, subsidized partially by television.

In contrast to the Club des 13's pessimism, *Irreversible* also showed how individualistic and creative producers could still contrive financial packages that offered someone like Noé – a loose cannon if ever there was one, or at the very least an untried proposition on a production of this scale – a sizeable canvas, a foothold in the French film industry. To the key question – how could such a combative film as *Irreversible* contrive such a mainstream financial arrangement? – the answer is: through the work of Noé's producer, Christophe Rossignon. Rossignon, in fact, is one of the cadre of artistically inclined, adventurous financiers who to many eyes (although not those of the Club des 13) maintain the energy and diversity of the French film industry. Rossignon's signature, breakthrough production was backing and organising funding for Mathieu Kassovitz's *La Haine*, in 1995. He has since worked with, and facilitated the advance of, some of France's leading talents, including Laetitia Colombani, Philippe Lioret and Carine Tardieu. When I interviewed Tardieu, in 2013, she reported a similar funding set-up to Noé's on *Irreversible*. The talent-spotting Rossignon, a regular attendee of short film festivals, had seen her early work and approached her to ascertain whether she had a feature project in preparation;

the relationship led to fruitful collaborations with major stars (Karin Viard and Kad Merad for Tardieu's tender debut feature *La Tête de maman* [2007]; Vincent Cassel and Monica Bellucci for *Irreversible*), which then prompted pre-purchase deals from domestic and international distributors, substantial commercial investment, even from allegedly conservative television networks, and unexpected money to spend on a highly personal film project (Palmer 2013b). Returning veteran auteurs reliably grab the headlines, but a critical generative process in French film comes from this equation. Demonstrated by the rising fortunes of figures like Noé and Tardieu, the paradigm of ambitious producers and venturesome stars seeking out collaborations with promising new writer-directors is at the core of how contemporary French cinema renews itself, and grows.

Another key trend in the French film business, which accelerated during the first decade of the twenty-first century, also affected Noé's career both professionally and personally. This is what in retrospect can be described as the large-scale feminization of French cinema, begun in the context of much late-1990s national attention upon gender imbalances within France. Lucille Cairns points to an especially catalytic July 1998 *Le Point* study, which found French women suffering serious inequities at both home (French men did less than a third of all parenting and housework), in the workplace (where French men earned 22.5% more than their female counterparts), and most egregiously in the political arena (only 10.9% of those in office in France were female, the second-worst proportion in the whole of the European Union [EU], above only Greece) (Cairns, 2000, p. 82). Public debate, exacerbated in the wake of the 1989 French Revolution bicentennial, intensified, resulting in sweeping political reforms that especially prioritized greater *parité* among political candidates (Palmer, 2013a, pp. 152–153; Célestin et al., 2003, p. 1–16). The *parité* campaigns gained surprising traction in the French film business, which historically – with isolated exceptions like Alice Guy, Marie Epstein, Jacqueline Audry, and Agnès Varda – had until the late 1960s been mainly a bastion of male-centred professional privilege (Palmer, 2013a, pp. 64–75). During the 2000s,

the picture changed quite dramatically: as Carrie Tarr reports, from 2000 to 2010, 413 out of 2,260 French films (18.3%) were directed by women, almost doubling the totals from previous decades. In 2002 alone, the rate of female film-makers completing features jumped nearly 5%, from 12.6% to 17.1% (Tarr, 2012, pp. 189–191).

While *Irreversible*'s on-screen treatment of gender relations, as we will see later, is far from harmonious, this rising profile of French women film-makers relates intimately to Noé's creative emergence, in the form of his wife and professional partner, Lucile Hadzihalilovic, whose career course parallels and informs Noé's own. Like Noé, Hadzihalilovic is a product of France's film school system: she graduated from IDHEC in 1986, the same year the institution was re-launched as La Fémis with a new mandate to pursue gender parity in its director track, a recruitment ideology that proved a key reason for the growth of France's women film-making population. Soon after, in 1991, Noé and Hadzihalilovic jointly set up a production company, Les Cinémas de la Zone, based on the rue du Faubourg Saint-Denis in Paris, which underwrote their artistically entwined series of collaborations that followed. Hadzihalilovic's approach, from one perspective, connects to what Tarr and Brigitte Rollet take to be a major strand of practice in French (women's) cinema. This is the feminine coming-of-age film, focalized around the point of view of young girls or fledgling women, a model that works conceptually by 'evoking nostalgia and longing for a lost, imagined world ... [or else] evoking anger and pain at past disillusionments ... [such films'] foregrounding of the perceptions of child or adolescent protagonists whose experiences are normally marginal and marginalized has the potential to challenge hegemonic adult modes of seeing' (Tarr with Rollet, 2001, p. 25). (This notion of film-making that challenges dominant viewing practices reads in hindsight like a rallying call for Les Cinémas de la Zone's roster of productions.) Some of France's richest women-authored films, beginning on a larger scale in the 1970s, continuing ever since, follow this trajectory of neophyte-adult portraiture. These include some of French cinema's most passionate works, including

films both little seen and iconic, from Nina Companéez's *Faustine et le bel été* (1972), to Catherine Breillat's *A Real Young Girl* (1976; undistributed until 1999), Agnès Varda's *L'Un Chant, l'autre pas* (1977), to Diane Kurys's *Peppermint Soda* (1977) and *Coup de foudre* (1983).

Like Noé, while Hadzihalilovic's applied cinephilia connects her directly to historical antecedents, her work seeks to radicalize the familiar, to destabilize the generic or conventional. Noé and Hadzihalilovic, especially in the collaborations that I shall return to later, once again attend carefully to hereditary French film protocols, but infuse them with their own assertively cinematic methods, often pursuing drastic perceptual experimentation as much as stable diegetic worlds inhabited by plausible human beings. Hadzihalilovic's feature debut, *Innocence* (2004), in particular is a fascinating companion piece to *Irreversible*. Both films are profoundly shaped by the input of Benoît Debie, using intrusive cinematography to create oneiric, largely hermetic diegetic worlds, lyrical but unsettling liminal spaces with little or no grounding in a mise-en-scène of contemporary France. Shot, like *Irreversible*, murkily on Super 16mm with digital colour highlights added in post-production, but, unlike Noé's film, using only natural lighting and reflectors, *Innocence* depicts a year in the life of a girls' boarding school, secluded in a remote forestland, where young girls arrive in coffins to study biology and dance (Palmer, 2011, p. 168–177). A wonderful study in restricted narration, limited like Henry James's *What Maisie Knew* (1897) to an oblivious child-based perspective (rumours circulate that the school's staff are all failed escapee children, working in captivity ever since), *Innocence* is far more understated than *Irreversible*, ambivalent rather than incensed, but nonetheless turns the feminine coming-of-age film template into an insidious sense of repressed trauma, social isolation and/or deviance and pent-up estrangement. After its final shot, which fades to black – like *Irreversible*, *Innocence* concludes on an energising source of cascading water: a stone fountain in the latter, a park sprinkler in the former – Hadzihalilovic ends with the simple dedication 'À Gaspar.' This personal, but also transtextual, cue alerts us once again

to the proximity of two contemporary film-makers whose materials are interwoven, intersecting, even bisecting.

The final point to raise about the contexts proximate to *Irreversible*'s 2002 emergence comes from an issue often overlooked in film studies, a shaping force that is in fact especially salient to contemporary French cinema. This requires us to (re-)conceive French film craft to be in large part driven by conversational practice. Instead of taking (as is regrettably common) a film system like France's to be a simple dichotomy – commercial drones unthinkingly recycling generic materials, on the one hand, versus individualist auteur mavericks attuned only to their own artistic urges, on the other – we should look more objectively, conceiving the French ecosystem as populated by highly attuned film practitioners engaged by shared protocols, interconnected professionals nuancing and revising inherited film norms. Hence French cinema is a network of film-maker peers in collective dialogue, rational agents mutually engaged by each other's works, a group dynamic in which film-makers respond and retaliate to cinematic ideas unfolding in progress around them. Draw upon the past, sustain the present, nurture the future. On a small scale the Noé-Hadzihalilovic partnership is one such obvious engagement, but the trajectory emerges more systematically still.

For our purposes here, in terms of Noé's conversational position, two major film productions resonate. This duo, spectacular and hotly debated commercial successes that reconfigured French film-making thereafter, are Jean-Pierre Jeunet's *Amélie* (2001) and Christophe Gans's *Brotherhood of the Wolf*. While Noé was in pre-production on *Irreversible*, these films dominated the annual conversation about the prospects of French film: *Amélie* was the biggest French-produced hit of 2001, second only to *Harry Potter and the Philosopher's Stone* (2001), with 8.6 million paid admissions, while *Brotherhood of the Wolf* placed sixth overall (second to *Amélie* in terms of French productions) with 5.2 million tickets sold. From the perspective of stimuli to *Irreversible*, *Amélie* is a fascinating foil, really an antithesis or nemesis, while *Brotherhood of the Wolf* emerges more in terms of avenues opened up, representational and technical inspirations selectively embraced.

Amélie was a domestic and international sensation beloved by audiences. Noé – while acknowledging Jean-Pierre Jeunet in an interview as a committed stylist – clearly despised it. During the film's initial run in spring 2001, however, *Amélie* was widely hailed by a range of cultural critics, while it revived the fortunes of its co-writer/director after mixed reactions to his North American project, *Alien Resurrection* (1997). The *Amélie* phenomenon hinged upon a set of distinctive and beguiling motifs, mimicked by many French film-makers thereafter, attacked wholesale by *Irreversible*. There is firstly the figure of Amélie herself, played by emergent star Audrey Tautou, Jeunet's impish but largely sexless waif, an unstoppable plucky seeker-heroine with pursed lips and bobbed hair whose benevolent antics reinforce the benign, nostalgic evocation of community within her Montmartre *quartier*, centred upon her traditionalist café workplace. Underlining her tireless creative poise, Amélie even gets to make occasional rejoinders to André Dusollier's omniscient voice-over which structures the film. *Amélie* was also known, initially celebrated, for its digitally enhanced aesthetic, a stylistic charm offensive characterized by Ginette Vincendeau as an 'arsenal' of 'exaggerated sounds, a saturated colour scheme, abrupt changes of scale, huge close-ups of objects or faces balanced by long takes that use intricate camera movements' (2001, p. 24). On-screen in this film, even the sex shop in which Nino (Kassovitz), the object of Amélie's affections, works, exudes a warm, enticing, lavishly detailed mise-en-scène. Jeunet also builds *Amélie* around one of his other trademarks: archly comic disclosure montages, which are used for two primary purposes. The first is *Amélie's* slew of infamous like/dislike backstory introductions, in which fragments of character interiority yield engagingly overt protagonists, human beings deciphered and laid bare, made delightfully transparent. Amélie's father, for instance, in 55 seconds of screen time emerges neatly as a control freak: he hates urinating while standing next to someone else, noticing scornful glances cast at his sandals, and wearing clinging wet swimming costumes; he loves tearing off long strips of wallpaper, lining up and polishing his shoes, and emptying, cleaning and rearranging his toolbox. The second, related use

of these playful montages is to reinforce Amélie's access to and agency over a Parisian population rendered orderly, homogenous and easily readable – such as the sequence in which she discerns that 15 orgasms, sequentially depicted in brief insert shots of short operatically sung climaxes, are taking place at that precise moment in time.

While *Amélie*'s amber-hued version of Paris might in early 2001 have seemed pervasive, angry dissenting voices soon begged to differ. In a country that prides itself on spirited public denunciations, from Émile Zola's 'J'Accuse' in 1898 to Truffaut's 'A Certain Tendency of French Cinema' in 1954, *Amélie* soon found itself the target of fiercely articulated derision; *Irreversible* in turn emerges as an unheralded final salvo at Jeunet's landmark creation. Iconic critic Serge Kaganski, in a rebuke titled sneeringly with a line from the actual film, 'Amélie pas jolie', was first in line, arguing that Jeunet's film was 'totally disconnected from all contemporary reality', cleansed of ethnic diversity and any social problems with a broad CGI-derived brush of smug totalising right-wing bluster (2001). Philippe Lançon, publishing like Kaganski in the leftist paper *Libération*, followed suit, calling out *Amélie* as a conservative cartoon, an ultimately sinister ploy to 'transpose Euro-disney to Montmartre: same logic, same enchanted trompe-l'oeil, same use of figurines, same sadness disguised as joy' (2001). As Elizabeth Ezra wryly concludes, *Amélie* certainly is guilty of working diligently to 'erase, as if by magic, all traces of graffiti, crime, pollution and social unrest' (2008, p. 86). The homeless man who gently refuses Amélie's offer of money, on the grounds that he never works on Sundays, is perhaps the ultimate distillation of Jeunet's logic.

Politics aside, though, an important stimulus – or a source of cinematic outrage – transferred from *Amélie* to Noé comes from Jeunet's underlying cinematic model, if not his actual ideology: of human psychology conceived as ingratiating and knowable, a communal vision of Paris that is a painterly continuation of the past. As a driving force of human behaviour, *Amélie*'s treatment of sex and sexuality is in particular wholly regulated and sanitized, a whimsical backdrop to a beautified Paris of tidy streets, clean

apartment buildings and mutually connected humanity. Whether it is the artfully obscured breasts of Nino's (content) co-worker performing pole dances before clients in an immaculate sex parlour; or Dominique Pinon and Isabelle Nanty's bathroom copulations creating a humorous jouncing rhythm that permeates the adjacent café, rippling wine and bouncing straws while Amélie smirks delightedly to camera; or, indeed, the (non-)climactic pecks on the cheek and static cuddle (after we see their silhouettes undress discreetly behind a curtain) shared by Amélie and Nino in bed near the film's ending, *Amélie*'s diegetic world is fundamentally chaste, devoid of uncertainty, legible and predictable, as regimented as it is aestheticized. It is this dynamic of mise-en-scène and cinematography, unified in form and content, that makes *Amélie* a kind of enemy text to Noé, opposed to everything *Irreversible* pursues. Jeunet demurs; Noé blitzes.

Amélie induced Noé's creative wrath, but *Brotherhood of the Wolf* offered a more nuanced, productive influence upon *Irreversible*'s development. Firstly, there is the fact of Gans's film's peculiar but extremely successful (grossing $70 million internationally on a $29 million budget) hybridity, marrying multiple genres and three apparently incompatible international production sources: Asian-derived kung-fu aesthetics, a kinetic editing style borrowed from Hollywood action pictures, and a very traditionalist use of French heritage film design. While its plot invokes actual historical rumours – the hunt for the so-called Beast of Gévaudan, a legendary creature accused of devouring more than 100 people between 1764 and 1767 – *Brotherhood of the Wolf* is ultimately a kind of high-profile pastiche, forceful but also facetious about the trappings of the usually po-faced historical genre, an engagingly erratic transnational super-production composite.

Many of *Brotherhood of the Wolf*'s textual strategies were through its success propelled forcibly into the French film mainstream, making them overt points of departure for Noé in 2001. One specific feature is the star pairing of Cassel and Bellucci, never more prominent, never more exaggerated and sexualized in their performances, which verge frequently

on (arguably knowing) farcical caricature, playing, respectively, an incestuous rapist degenerate aristocrat and an undercover Papist spy masquerading as a high-class prostitute. Although they are kept apart for almost all the film, this characteristically outlandish Cassel-Bellucci starring double act would function, as we will see later, as one particular key to *Irreversible*. In broader aesthetic terms, as Laurent Jullier and Lucy Mazdon observe, there is also the fact that Gans's film, accompanied by *Amélie* and Alan Chabat's *Astérix et Obélix: Mission Cléopatre* (2001), instantiated digital technologies as a striking new trade norm in France. Alongside Pitof's *Vidocq* (2001), putatively the first ever entirely computer-rendered feature production, its mise-en-scène derived exclusively from green screen shooting, this group of films in hindsight marked nothing less than 'a turning point in French cinema…the latest phase in an ongoing game of technical/aesthetic one-upmanship with Hollywood' (2004, p. 228). Although CGI augmentation permeates *Brotherhood of the Wolf*'s design, the film's absurdly mobile sixth shot, two minutes in, which triggers its framing flashback, is particularly significant for contemporary French (and indeed global) cinematography; Noé was obviously enthused. The digital composite sequence shot starts out as a sped-up helicopter shot, Gans's camera traversing aerially lush green French hinterlands and rolling moors at increasing velocity, before then impossibly bisecting a tight rock crevasse, careening at breakneck speed down a gully, then tracking finally a fleeing peasant who is stalked by Gans's murderous beast. Digital cinema outings like this, the prospect of giddily kinetic, rampaging virtual long-take excursions through space, would eventually coalesce at *Irreversible*'s queasily beating heart.

In important ways, as instigator or catalyst productions, both *Amélie* and *Brotherhood of the Wolf* became peers in an unlikely sea change that transformed early twenty-first-century French cinema. This is a mass, large-scale movement away from the prevailing realist aesthetic so long associated with French film-making, from the famously socially engaged 1930s poetic realism template, to the anti-studio amateur collective style of much of the French New Wave, to the 'New Naturalism' of the 1970s and 1980s

inspired by figures like Jacques Doillon, Jean Eustache, Maurice Pialat and many others (Smith, 2005, pp. 74–112). Certain *cinéma du look* films of the 1980s and 1990s, inspired by Besson (*Nikita* [1990]), Jean-Jacques Beineix (*Betty Blue* [1988]) and Léos Carax (*Bad Blood* [1986]), may have started this ball rolling, but the approach in the early 2000s metastasized. As digital technologies became cheaper and ubiquitous, moreover, so concomitantly did aesthetics of distortion, manipulation and exaggeration spread rapidly in France, especially among younger film-makers. Whether it was for boosting the commercialist production designs of spectacular mainstream cinema, or expanding the conceptual visual palette of film-makers like Noé, anti-realist digital cinematography changed the course of French film. Carax's dazzling *Holy Motors* (2012) can now be seen as the epitome or linchpin of this new French anti-realism, but examples are everywhere, in all areas of media production, art house to multiplex, from Valeria Bruni Tedeschi's *It's Easier for a Camel* (2003) to Michel Hazanavicius's *OSS 117: Cairo, Nest of Spies* (2006), from Valérie Donzelli's *Declaration of War* (2011) to Michel Gondry's *Mood Indigo* (2013).

An additional preliminary conclusion here is the extent to which, yet again, *Irreversible* emerges as a profoundly French film, shaped on all sides, both positively and negatively, by the moving plate tectonics of the French film industry, on- and off screen. Noé himself, alert to and engaged by the film landscape around him, distils these sources like a cinematic Geiger counter, responding to stimuli with his own bizarre, eccentric, intermittently familiar yet peculiar body of engagements. If *Irreversible* is undeniably a limit case for contemporary French cinema, a point to which very few film-makers would reach, let alone pass, it is also a testament to and reflection of the very rich diversity of the French cinema ecosystem as it advanced tentatively, yet oftentimes with tremendous panache and flair, into the twenty-first century.

✕ PART 2

IRREVERSIBLE AND THE *CINÉMA DU CORPS*

Alongside the wholesale changes affecting the French film industry by 2002, there was a major conceptual tendency connected to Gaspar Noé's work, culminating in *Irreversible*. This is the onset in France during the late 1990s and early 2000s of a truly remarkable and oftentimes antagonistic phenomenon, the *cinéma du corps* (cinema of the body) (Palmer, 2011, pp. 57–93). Again, it is tempting to assume that a body of work as strange as Noé's must be intrinsically auteurist, unique and set apart from any prevailing currents in French cinema at the time. Maintaining the focus upon French film-making as a continuum in conversation, however, an ecosystem of engaged practitioners, reveals a different picture. The *cinéma du corps* originated in France but soon radiated outwards internationally, manifesting, depending on your point of view, either as a source of inspiration or a contagion. *Cinéma du corps* productions would soon include some of France's most combative works, admired by enthusiasts, despised by detractors, with little room for compromise between each camp. Either way, while French cinema in the early 1990s had been languishing industrially – and arguably artistically – in the doldrums, the *cinéma du corps*'s arrival galvanized France's film community, provoking some of the most notorious productions to emerge for decades. French cinema, in other words, was back on the radar, essential again.

The *cinéma du corps* jettisoned peremptorily a lot of the established etiquettes of world cinema. To many of its respondents it voided cinema, reneged on the contract between film-maker and viewer, made the breach between European art cinema and classical Hollywood in the 1950s and 1960s look like a gentle preamble. So heated did the conversation soon become that it is worth unpacking up front the *cinéma du corps*'s agenda neutrally, focusing on aesthetics and style, spectatorial engagements, and conceptual commitments versus prevailing conventions in France's screen culture. There was no manifesto of purpose, no obvious shaping cadre of film-makers as with the French New Wave. What took place, instead, and is yet to conclude, is one of the most dynamic on-screen group conversations in the history of French cinema. The *cinéma du corps* took shape at traditional

film culture sites, through programming at more adventurous repertory film theatres or festivals drawn to controversy; it also benefitted from scrutiny by a large community attuned to a rapidly evolving home media environment: among online conversations and websites as the Internet spread, on home media as the reach of DVDs grew after 1998 in Western Europe and North America. Particularly in this latter sector, through home viewing and widespread access to diversifying media platforms, securing the attention of cinephiles unable to attend film festivals or benefit from urban centre programming, the *cinéma du corps* could consolidate and build momentum fast, arguably like no film movement before it.

The *cinéma du corps* itself can be constituted initially by the films that advanced this shared film discourse, many becoming – almost overnight – sources of backlash, but also collectively establishing a shared palette of principles. The films in question, an assaultive anti-canon, cut across all strata of the French cinema ecosystem. Gay and straight, senior and junior, newcomer immigrants and long-term French residents, male and female – the *cinéma du corps* mobilized a remarkably diverse body of practitioners; on this front it perhaps surpasses even French Impressionism of the 1920s, its closest peer in regards to cinematic achievement. Largely micro-budget, the *cinéma du corps* also features *films du milieu* like *Irreversible* and *Demonlover* (Olivier Assayas, 2002), underlining its logistical, as well as artistic, versatility. The leading titles, dates and film-makers are: *Select Hotel* (Laurent Bouhnik, 1996), *The Life of Jesus* (Bruno Dumont, 1997), *Regarde la mer* (François Ozon, 1997), *Don't Let Me Die on a Sunday* (Didier le Pêcheur, 1998), *Sombre* (Philippe Grandrieux, 1998), *I Stand Alone* (Noé, 1998), *Romance* (Catherine Breillat, 1999), *Lovers* (Jean-Marc Barr, 1999), *Baise-moi* (Virginie Despentes and Coralie Trinh Thi, 2000), *Trouble Every Day* (Claire Denis, 2001), *Intimacy* (Patrice Chéreau, 2001), *The Pornographer* (Bertrand Bonello, 2001), *In My Skin* (Marina de Van, 2002), *Demonlover*, *Irreversible*, *Secret Things* (Jean-Claude Brisseau, 2002), *Twentynine Palms* (Dumont, 2003), *Dancing* (Patrick-Mario Bernard, Xavier Brillat and Pierre Trividic, 2003), *Eager Bodies* (Xavier Giannoli,

2003), *Ma mère* (Christophe Honoré, 2004), *5x2* (Ozon, 2004), *Les Invisibles* (Thierry Jousse, 2005), *L'Annulaire* (Diane Bertrand, 2005), *L'Histoire de Richard O.* (Damien Odoul, 2007), *Enter the Void* (Noé, 2009), *Le Sentiment de la chair* (Roberto Garzelli, 2010), *Des filles en noir* (Jean Paul Civeyrac, 2010), *Q* (Bouhnik, 2011), *The Strange Colour of Your Body's Tears* (Hélène Cattet and Bruno Forzani, 2013), *Bastards* (Denis, 2013) and *Flesh of My Flesh* (Denis Dercourt, 2013). Among the above, film-makers like Breillat, Denis, Dumont, Grandrieux and Noé emerge as figureheads, probably the most sustained adherents to *cinéma du corps* tactics; others engage its motifs diffusely or intermittently. But make no mistake, this constellation of productions left traces throughout the modern French film ecosystem. From the archly self-referential and philosophically saturated (such as Breillat's meditation on filming the sex act, *Sex is Comedy* [2002]), to the facetiously digressive (Nicolas Boukhrief's black comedy portmanteau *Le Plaisir... et ses petits tracas* [1998]), the *cinéma du corps* has redirected the course of much contemporary French cinema; its reach is piercing. Subsequent to an initial surge of activity in the 1990s, the *cinéma du corps* decades later has now taken its place as a fixture in the French film ecosystem. Its ideas about film design have permanently flavoured the groundwater, making it in fact a perpetual point of departure – one current among many – for France's more committed film-makers to consider.

With these productions in mind, though, it is vital to reiterate: the conversational tenets of this *cinéma du corps* merit careful scrutiny and rational analysis to assess its materials. Critics often bandy about words like 'extreme' or 'extremist' as a defining first response, an essential way into categorizing these films, but we should if possible avoid such unhelpfully pejorative, marginalizing overarching terms. There seem to be no positive, or even neutral associations with 'extremist' at all – most misguidedly, it strongly connotes lost control, an inability to be measured and precise, which is actually crucial to the film-makers in question. In fact, so fundamental is the diegetic recalibration of the world on-screen here, both aesthetically and conceptually, that one truly arresting effect of the *cinéma du corps* is that it

normalizes its materials so as to be utterly plausible, inevitable even, and – most trangressively – logical and innate. More broadly, the *cinéma du corps* is far from being a demented back eddy of film practice – it actually revived 1990s French cinema, inspiring practitioners and writers ever since, doing so crucially from a position of fundamental connection, as an artistic reagent, a stimulus. When Richard Falcon astutely spotted facets of the *cinéma du corps* emerging as early as 1999, based in part upon films with an 'aggressive desire to confront…audiences, to render the spectator's experience problematic' (1999, p. 11), it was also most vitally an expanding vanguard of film-makers who felt, and still feel, this creative challenge, this call to arms, this need to reinvigorate and rethink their future work.

History here – as always – repeats itself. For during its most dynamic periods, notably the 1920s and 1960s, French cinema (from there exerting its typical international influence) has historically maintained an avant-garde contingent (Grant, 2013, pp. 100–109) that crucially then informs, enters into, many of its interrelated sectors of production. In a sensitive film-making ecosystem like France's, counter-cinemas rebel, but they also concomitantly overhaul, creatively renewing more conventional forms of culture. The *cinéma du corps* may be radical, then, but it actually seeds future film and media practice. When, for example, the escalatingly complex romantic drama, *À coeur ouvert* (2012) uses, for both its trailer and a pivotal romantic scene, Édgar Ramírez and Juliette Binoche kissing passionately through a plastic sheet, the resonance from our *Irreversible* shower scene, discussed already, looms large. Equally, when near the opening of the major 2010 hit *Little White Lies* Guillaume Canet stages a very long take steadicam tracking shot, at night, following at speed Ludo (Jean Dujardin) on his scooter, who is then blindsided and mortally injured by a truck that irrupts violently into the frame from off-right, inspiration has come from Noé and Debie's innovative cinematography. In the same way, *Irreversible*'s pungent signature mise-en-scène subtends a linchpin setting of Fabrice Gobert's brilliant television series *The Returned* (2012–; derived from Robin Campillo's 2004 *They Came Back*; see Palmer, 2011, pp. 132–138), in which a

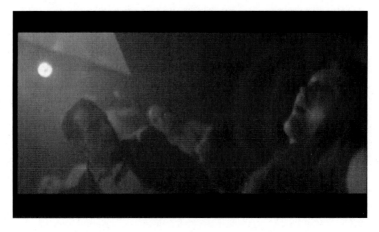

Figure 2: Pierre abruptly commits murder, a representative eruption of *cinéma du corps* violence, in The Rectum in segment 2

psychopath stabs women in a murky yet fluorescent-lit underpass; Gobert's design also showcases a discombobulating Noé-Debie photographic flourish when three characters try to traverse a mountain tunnel's roadway by car. The *cinéma du corps* is artfully confrontational, absolutely, but it is a component part of French (and by extension international) cinema and television: a dynamic catalytic contingent that inspires dialogue, not an isolated group of ghettoized vandals or hysterics.

Faced by the *cinéma du corps* it is also important to remind ourselves that film really can be or do anything – any length, any design, any relationship with an audience paying or otherwise. Usually what we encounter are just norms, commercialized habits of a domesticated cinema, whose traits are unthinkingly perpetuated and treated at face value as unyielding rules: The Way Films Behave. So automatic are most objections to the *cinéma du corps*, that it really takes us back to foundational arguments about the status of film as nothing more than disposable entertainment, *movies*, a production line of manufactured distraction–attractions

fundamentally distinct from proper art forms, literature most obviously, which by contrast endure, become canonical, and hence warrant serious thought. Overconfident critics, especially those offended by the *cinéma du corps*, are inclined towards totalizing conclusions about cinema as a medium in a way few would about painting, or sculpture, or theatre or writing. If nothing else, studying the *cinéma du corps*, *Irreversible* and its sister films, gets us back to those basic issues, long since driven underground but festering still, about the essential nature and configuration of film, whether it can or should attain respectability.

So what does the *cinéma du corps* do? How does it work? What are the means of these cinematic transactions? The opening of *Don't Let Me Die on a Sunday*, in retrospect an influential early *cinéma du corps* test case alongside *Romance*, *Select Hotel* and the first wave of peer releases, introduces a bold, abrasive agenda. The film's opening credits are set to black, under which a subterranean thump, like an adrenalized heartbeat, pulses. A skittish hi-hat percussion refrain insinuates into the sound mix, as le Pêcheur intercuts stroboscopic medium shots of a wild nightclub and the dim basement of a mortuary. Electronic droning and harder drums, then a grating guitar lick, build on the soundtrack. Amidst constant flashes of light we next see Térésa (Élodie Bouchez) on the dance floor, in rapture, taking drugs, interwoven with indistinct medium shots of a threesome happening hastily on an autopsy slab. Ben (Barr) stands, looking on blankly, while Boris (Patrick Catalifo) has sex with Marie (Jeanne Casilas): their coupling is impersonal, abruptly ended, only hazily consensual. Ben meanwhile holds Marie in his arms in a gesture somewhere between restraining and embracing her; she looks at him, unresponsive, then turns her head implacably away from both men. Intercut to the same pounding diegetic rhythm, Térésa's trance, engulfed in the music, soon becomes sinister. Her movements cease; she too raises her face upwards; her eyes glaze over. Seconds later her body, dishevelled with sweat, falls to the floor to lie horizontally; the camera arcs down to follow her but no one else attends to, or seems to notice, her collapse. Over the title caption, two-and-a-half minutes in, we finally

hear the first spoken words – Ben's contemptuous line: 'Fuck, every day is as pointless as the next'. The film that follows, erratically yet relentlessly executing this voice-over's logic, is essentially the numbed, failed hedonist Ben's path to self-murder.

From *Don't Let Me Die on a Sunday* onwards we can outline some shared practices, techniques in common even among such a dissident group. First, there is the matter of *cinéma du corps* humanity. Its protagonists are not likeable, they do not ingratiate with their deeds, they are not presented as role models, do not evolve or solve problems, are not socially engaged, are typically nihilistic outsiders. Sometimes they are blank ciphers without any discernible psychological profile at all. Charming readable agents of narrative, whose contrived construction – archetypally Rick (Humphrey Bogart) in *Casablanca* (1942), say, or Jerry (Tom Cruise) in *Jerry Maguire* (1996) – is actually highly artificial, normalized only by sheer repetition, familiar from most international as well as North American cinema, dissipate into nothingness here. Already, this insistent model of characterization, eschewing age-old traditions of film representation – make your hero a seeker-protagonist, wronged initially, vindicated by film's end – proves itself endlessly objectionable. Heads butt against that most enduring of critical clichés: *There's no way to appreciate a film if I can't relate to and enjoy the main character/s*. On the contrary, the *cinéma du corps* approaches, in Thomas Elsaesser's evocative view, through its 'abject heroes or heroines', nothing less than 'the conditions of possibility of a counter-image of what it means to be human' (2005, p. 125).

Among one strand of the *cinéma du corps*, moreover, especially with regards to its subspecies of male-focalized main characters, so inchoate and violent are these protagonists that in productions like Odoul's *Le Souffle* (2001), Grandrieux's *Un Lac* (2008), Romain Gavras's *Our Day Will Come* (2010) and Dumont's *Hors Satan* (2011), on-screen masculinity reverts to a disturbing kind of wilderness condition, with atavistic and peripatetic figures situated completely outside the perimeters (and parameters) of contemporary French civilization itself (Palmer, 2014). But it gets worse.

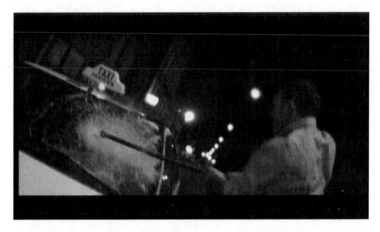

Figure 3: An enraged Marcus vandalizes a taxi in segment 3, hysterical deeds prevailing over reasoned thought, in keeping with the *cinéma du corps*

Sometimes with both genders for almost the entire film (like Coré [Béatrice Dalle] in *Trouble Every Day* or André [Samuel Boidin] in *Flanders*), often for long crucial stretches during which we might crave (and expect) psychological insight (an apparently traumatized Esther [de Van] in *In My Skin* or Bruno [Laurent Lucas] in *Les Invisibles*), these *cinéma du corps* protagonists do not speak, they do not vocalize: they simply incisively, remorselessly, inexplicably act. (Non-professional performers, unskilled or unable to emote before the camera, therefore make very effective tools among film-makers like Dumont and Breillat.) Even in scenes in which uttered dialogue figures, moreover, it is frequently counteracted by assertive sound mixes (here Dumont is a pioneer) in which the human voice is unmoored from its customary aural dominance at the top of the sound hierarchy, and relegated to the status of just one competing strand of noise among many. Sometimes, clearly in English-language versions of *Irreversible* (pointedly its second segment in The Rectum), the *cinéma du corps* by consequence mounts intriguing problems for subtitlers seeking

to prioritize particular lines within diegetic cacophonies – which lines matter? – as voices are drowned out by ambient currents; the usual human capacity to pronounce commentary or judgment is cinematically offset, broken, undermined. More broadly, too, that most deep-seated and longest-serving of all of French cinema's hallmarks, its witty scripts and constant on-screen banter, is profoundly, ominously stilled. Indeed, if French cinema has perennially been accused (sometimes by *cinéma du corps* film-makers like Breillat) of catering to a bourgeois mindset, producing endless middlebrow comedies of manners or romantic-sexual farces, the drawing room niceties of Eric Rohmer's moral comedies are hereby desecrated, left to ruin.

At the level of narrative the *cinéma du corps* also transgresses; it instantiates discord. Stripped of logically motivated and/or conveniently goal-oriented protagonists, these films alternate protracted sequences of neutral or dead time with flare-ups of barely controlled, inexorably erupting hysteria and violence. If classical narrative is typically described as a causal chain, then the *cinéma du corps* analogically consists rather of disparate coils of barbed wire, broken fragments that hideously scrape together. Blank impassive states, of physical places and the people existing there, oscillate with heightened cacophonies. The opening minute of *Sombre* is highly representative: for his literal and conceptual preface Grandrieux cuts from barely legible DV-derived nightscapes of a car on a rural road, its engine exuding a dull rumble, to medium close-ups of shrieking, incandescently enflamed children. (Only much later are these mutually incompatible stimuli related: the man in the car is a serial killer of women; the children are the audience before one of his puppet shows.) Dumont's *Twentynine Palms*, which vies with *Irreversible* as the least-liked of the *cinéma du corps*, also exemplifies this narrative model of numbing protracted duration interspersed with instances of garish arousal. It uses extended scenes of a barely communicative couple driving, walking, traversing an almost abstract (Californian) desert landscape, into which intrude intensely enacted, consensually or otherwise, sexual climaxes. Harsh diegetic stimuli conveyed cinematically, like the throbs of light and sound in the opening

of *Don't Let Me Die on a Sunday*, crucially replace higher cognitive cues like verbal declarations, or actions linked to processes of psychology or thought. Within hostile on-screen worlds, by consequence, *cinéma du corps* behaviours are arrestingly uneven, frequently contradictory. *Cinéma du corps* humans are assertive and (violently) decisive to the point of rash impulsivity, yet mediated by no obvious rationality, uncompromised, bound to no social contract. One causal mechanism here is that often, as with Dumont, Denis and Noé for *Irreversible*, *cinéma du corps* film-makers jettison conventional scripts and scriptwriting, preferring instead brief treatments with pivotal lines and plot points only, the rest of the narrative to be configured during the shoot and post-production. (In interview, Denis has stressed many times that for her cinema is a process of replacing words on a page with images and sounds on a screen; critics rushing to interpret her work, sometimes laboriously so, ignore this point, Denis's actual formalist passions, often [see Kaganski and Bonnaud, 2001].) Suggestive incidents and accruals of sensations, henceforward, define these diegetic constructions more than three-act structures, lucid human agency, and the trimmings of classical narration. We might take, in sum, the *cinéma du corps* as a collective instantiation of protest against the repetitive strictures of formal screenwriting, those etiquettes of script design endlessly advocated by screenplay manuals and among conventional film instructors. To many, this is a welcome and liberating opportunity seized.

Pervading the *cinéma du corps*, disproportionately the cause of its most vicious denunciations, is human sexual behaviour rendered in the most devastating of terms. It is not just that sexual interactions here are no longer romantic, but that copulation and sexual exchanges in all their forms and possibilities, those most inherently intimate of all corporeal interactions, bodies literally conjoined, are depicted as no longer essentially mutual at all. Sex is antagonistic; shared bonding corporeal experiences are vanishingly rare; physical pleasure-deriving (never giving) is fraught with violence; procreation is inconceivable. The figure of Ben/Jean-Marc Barr in *Don't Let Me Die on a Sunday* is representative again: he is sequentially severed from

civilized urban society, desperate to glean consolation from the most brute physical satisfactions, principal among which is emotionless, futile and, ironically, barely gratifying, acts of sex. Alongside Ben stands Dumont's almost non-communicative protagonist, Freddy (David Douche) in *The Life of Jesus*. In one typifying shot Dumont uses a foregrounding medium close-up insert, taboo still in commercial American cinema, of a waveringly erect penis to show how Freddy is borderline impotent, hence constantly stressed, prone to frustrated anger as much as pleasure, before and during sex. These instances of actual bodies propelled by sexual urges – like the unsimulated sex depicted in *Intimacy* and implied elsewhere, as in Freddy's (body doubled) image in *The Life of Jesus* – merely reinforce how such physical jolts short circuit, failing to channel sexual impulses into meaningful adult relationships. Sex does not build from/into couplings; all that can be (perhaps) sated are recurrent fleeting physical compulsions.

In aesthetic terms too this corporeal cinema deploys bodies in the most stark, distanced, jarring, alienating of terms. The conception is of torsos and their outlying territories as matter, parts, splintered ingredient chunks of a whole; hence, genitals, a dysfunctional bodily piece like any other, can no longer work as signals of, or responses to, a thoughtful brain's habitual transmissions. Self-harm and self-mutilation, then, is one product of this inexorable train of (anti-)thought: like Esther's self-lacerations, lyrical yet brutally self-devouring, in *In My Skin* (Palmer, 2006b; Palmer, 2010; Tarr, 2006); or more legible instances of mind-body divorce represented through internally compromised figures, afflicted with severe mental or physical illness, in *cinéma du corps* productions like *Eager Bodies*, or films farther afield such as *As If Nothing Happened* (2003) or *Je Vais bien, ne t'en fait pas* (2006). (Again the *cinéma du corps* has porous borders, its devices spread to more mainstream treatments.) Rape of all kinds, or illegibly borderline consensual sex, like the opening of *Don't Let Me Die on a Sunday*, is a similarly related, inevitable course. Clinical corporeal gestures, like repeated obsessive washing, probing and scrubbing of body parts in *In My Skin* and *Trouble Every Day*, are another. And even within the *cinéma du corps*, this latter film

might then present as a limit case, in which Denis takes an unspecified medical condition (and science has no answers for the depraved conditions conveyed by these films) to precipitate two of its protagonists to seduce and devour innocent passers-by. In *Irreversible* corporeal cravings maim; in Denis's film, they kill.

Sexual behaviour and film style intersect to enforce the corporeal estrangement of the *cinéma du corps*. As in its guttural howls at moments of sexual climax – animalistic shrieks of solipsism rather than joy or passion, emblematized by David's (David Wissak) stylistically amplified grating screeches in *Twentynine Palms* – even at the level of sound, and sound mixing, the sex act is stripped of humanity and warmth, empathy. Linda Williams suggests how, versus its censored Hollywood counterpart, which remains waylaid in perpetual adolescence, French cinema's candid on-screen use of sex creates a whole new avenue of representation, like the learning of a second language (2008, pp. 258–259). Ozon has similarly suggested that graphically treated sexual exchanges, or most pointedly, sexual infractions, like Gilles (Stéphane Freiss) forcing sex upon Marion (Valeria Bruni Tedeschi) in *5x2*, as part of its inverted narrative of a marriage unravelling/forming, opens up a whole untapped path of representations. Ozon indeed argues for a core quality of the *cinéma du corps* itself: that, 'These are the moments when characters no longer project their discourse but reveal themselves through their bodies' (in Rouyer and Vassé, 2004, p. 43). But this new cinematic language, carnality laid bare, creates corporeal disclosures only of the most glaring, unflinching, unyielding kind – a sexual repertoire that broaches humanity's most inhospitable, most pitiless expanses.

Diegetic backdrop to the *cinéma du corps*, impressionistically glimpsed, is of a contemporary France in which the social contract no longer applies, in which society has without fanfare degenerated, devolved to vestigial traces. Underground nightclubs and riotous parties, from *Don't Let Me Die on a Sunday* to *Irreversible* (even encompassing the comparative banality, in *In My Skin*, of an office get-together), are therefore iconic spaces, in which hedonism prevails, intoxication inculcates detachment, and gratification

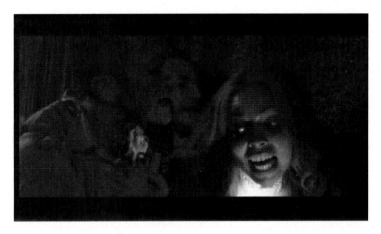

Figure 4: Marcus threatens Concha, under-lighting garishly exaggerating the intimacy of the violence, in segment 5

is the only thing that unites a crowd of people. Communion, hence community, takes place on this visceral, degraded, basis. France in the *cinéma du corps* is an environment where modern social constants and/or traditional saving graces – families, long-term romantic partners and marriage, children, parents, workplace colleagues, police and reliable law and order, safety-net armatures of the State like schools and social services – without commentary recede from view. (Years before the austerity discourse came to dominate European politics, it is as if the *cinéma du corps* already imagines a world in which all niceties of larger-scale or top-down civilization have gone extinct.) The *cinéma du corps's* treatment of social threat and crime is also fundamentally different from French cinema earlier in the 1990s. Whereas influential films like *La Haine* and *Ma 6-T va crack-er* (1997) showed festering youth-driven crime, they delimited its location source very specifically to the *banlieue* projects outside Paris's surrounding fence *périphérique* (Tarr, 2005, pp. 98–104); as Myrto Konstantarakos puts it, *La Haine* is predicated upon 'the spatial division between centre and periphery'

(1999, p. 163). The *cinéma du corps*, by contrast, understated but insidious, shows us violence and crime metastasizing, insinuated almost everywhere you look, especially within the confines of the Paris cityscape.

In the *cinéma du corps*, by consequence, the enduring screen stereotype of Parisian mise-en-scène – the city of lights as a socially secure picture postcard, a lure to global tourists – takes a malicious turn indeed. The sources of the menace, however, remain indistinct, uncertain, exacerbating the omnipresent sense of diegetic tension. As Jonathan Romney suggests, while occasionally particular social causes are signalled, like the extreme-right politics underlying Noé's *I Stand Alone*, or the cyber-pornography commerce of *Demonlover*, what is more essential here is a textual atmosphere of 'professional numbness in France, where a regimentation of workplace practices…creates a tightly gridded society that gives rise to violent responses' (2004). In addition, the *cinéma du corps* eschews any overt or didactic political statements; it defines no ideological hierarchy, which at a stroke antagonizes leftist film commentators, who search in vain for social(ist) interpretations as a means to recuperate these films. Just as the mechanics of political force are emphatically not at issue, in contrast, what is more deep seated is the climate of Paris and France at a grass-roots level, ephemerally lived, as the domain of predatory manipulations, in which moving bodies are inherently targets, sources – commerce aside – of corporeal revenue. As such, the *cinéma du corps* flies in the face of positive overarching sociological models; these films are entropic, unconvinced that time passing creates any tangible human or social advances. If anything people have regressed; they are like animals. *Irreversible* and its peers at a general level intuitively deny the conclusions of cognitive psychologists like Steven Pinker, whose global historical model predicates (with obvious exceptions) contemporary progress upon growing human sanctity: 'On top of the benefits that modernity has brought us in health, experience, and knowledge we can add its role in the reduction of violence' (2011, p. 694). Closer to home, the *cinéma du corps* is also unmoved by the overriding view from French sociologists, whose careful sifting of data – particularly the

baseline peak of raised unemployment in France of over 11% between 1993 and 1998 – confers social predictability, that violent crime outbreaks in Paris and beyond are measurable dynamics, a barometer gauge in which elevated joblessness induces elevated criminal activity (Fougère et al., 2009, pp. 909– 913). Not so in the *cinéma du corps*, whose unstable, anti-humanist diegeses represent Parisian life as a vulturine model, a social space of individuals defined as aggressors and prey, like Alex fatefully seized by Le Tenia.

Compounding all these textual elements of the *cinéma du corps* is its configuring visual and aural style: as primarily experimental, assertive and disjunctive. Again versus the dominant terms of French and world cinema – especially their continual (and still largely unchallenged) reliance on continuity editing, omniscient narration, declarative psychology and blatant cinematography, an aesthetic of ordered calm – the *cinéma du corps* prefers dissolution to wholeness, fragmentation to union and the jarringly incomplete to the organic (Palmer, 2006a). Sometimes *cinéma du corps* films (*In My Skin* and *Regarde la mer* notably) begin in quite classical fashion, but that template becomes splintered and incoherent climactically; sometimes classical unities are never present to any recognizable degree at all. Building from this, taking a theoretical perspective, the *cinéma du corps* can provide stimulating data. It might be, and has been taken, as one instantiation of Gilles Deleuze's broadly outlined post-war trajectory of 'Time-Image cinema', in which principally functional, denotational aesthetics were overhauled to become a more disruptive model of 'something too powerful, or too unjust, but also too beautiful, and which henceforth outstrips our sensory-motor capacities' (1989, p. 18). In Deleuze's footprints, Martine Beugnet similarly makes a case for some of the *cinéma du corps* as purveying an 'aesthetics of chaos' in which subject-object relations erode, and a liminal cinema of floating stimuli ensues (2007, pp. 112–113). But top-down approaches like these remain partial – we need additional contexts in order to ascertain the conversational generative mechanisms which create, and refine, the *cinéma du corps*. High theoretical templates tend towards the ahistorical, adrift from particulars of actual film craft in a defined time and

place; concomitantly they undermine or ignore the active human agency of conceptually engaged film-makers, figures making particular professional-artistic choices, responding to the ingenuity of their peers operating within a defined professional context. It is more productive – authentic – to conceptualize the *cinéma du corps*, however disconcerting and unusual, as the sum product of the agency of actual human beings existing in the world, rather than merely as a symptom of a trajectory in the cultural unconscious. Spend time with a contemporary French *cinéma du corps* film-maker, discuss their conception of film craft and the evocative materials at their disposal, and you discover a constellation of professional-artistic activity derived from rational human interventions. Such is the extraordinarily galvanizing practical-artistic force – received by filmgoers, critics, academics, cineastes and film-makers alike – of this area within the contemporary French film ecosystem.

Consider the wealth of stylistic (re-)configurations pursued by engaged expert *cinéma du corps* practitioners. One rallying group goal – on-screen, issuing from that screen to coalesce around the spectator – is to subsume any regulated dispensation of diegetic information to a lyrical, contingent disbursement of cinematic data. These experiments – although the notion of experimentation must convey the sense of tight discipline here – create surprisingly diverse results for the film viewer, that viewer (and listener) intensely sensorially engaged to a profound degree. Like all good (film) art, the *cinéma du corps* teaches us how to apprehend it, to divine its methods. Reversed narration patterns, for instance, as in *5x2*, can invert an imploding marriage into a course towards blissful courtship and love as a perpetual starting point: Ozon's film ends with its doomed central couple's first encounter, walking into the sea, happy ever before, bathed in a kaleidoscopic swathe of dancing sunbeams, one of the most beautifully twisted endings in recent world cinema. While intermingling high and low film cultural materials into a pop-art conceptual mélange has become widespread in contemporary French cinema (Palmer, 2011, pp. 95–149), even more bizarrely affective cross-pollinations of genres, modes and

inter- (even trans-)national formats energize sectors of the *cinéma du corps*, flavouring its group authorship. This might take the form of a French film-maker's (Dumont) imbuing an Americanized road movie with the trappings of backwater French rural horror (itself a reinvigorated genre in contemporary France; McCann, 2013, pp. 276–283); or Denis's combining the tenets of body horror with elliptical philosophical underpinnings; or pulp exploitation thrillers with overt pornography motifs recalibrated as searing feminist tracts (*Baise-moi*); or highly stylized manipulations of Italian *giallo* made in a *cinéma du corps* stylistic register (*Amer* [2009], *The Strange Colour of Your Body's Tears*). Bravura formalist designs underwrite, and amplify, the sense of cognitive and categorical entropy that is a *cinéma du corps* norm. All of this adds momentum to the critical confusion, hence dismissal, of texts like these that are frequently anti-associational at the level of shot, sequence, generic citation and overall address to the viewer.

A final, culminating way to define *Irreversible* and the *cinéma du corps* is by what it emphatically is not, what it broke away from, the preceding French cinema it dismantled. Beforehand was the calm before the storm.

Figure 5: Exemplifying the stylistic experimentations of the *cinéma du corps*, a study of gyroscopic motion in *Irreversible*'s cinematography, one of Noé's punctuating motifs, a frame that explores on-screen vectors of contextual space rather than the actions of diegetic humans

To most historians, in fact, 1980s and 1990s French film was dominated by heritage cinema, widely exhibited films like *The Return of Martin Guerre* (1982), *Jean de Florette* (1986), *La Gloire de mon père* (1990), *Cyrano de Bergerac* (1990), *Tous les matins du monde* (1991), *Germinal* (1993), *La Reine Margot* (1994), *Le Hussard sur le toit* (1995) and *Ridicule* (1996). In Dayna Oscherwitz's account, this saturation of heritage films offered 'a way of conceiving of the nation as a cultural community, formed by common historical experiences…privileg[ing] collective memory, which it presents as the guarantor of national stability and integrity' (2010, p. 13). Focusing especially on 1990, 'the year of the heritage film', Phil Powrie contends further that such 'official' French productions – then-Minister of Culture Jack Lang publicly endorsed *Germinal* in 1993 – embodied the Cultural Exception discourses of France versus Hollywood film imports, especially during the 1993 General Agreement on Tarifs and Trade (GATT) trade negotiations (1999, pp. 4–5). Heritage cinema therefore came to connote determined (national) prestige and pride, cultural legitimacy and a broad aesthetic appeal based upon traditionalist features. Even in these films' darker moments they merely frame familiar complaints about class privilege disparities; most of the time they are eager to please.

The difference between French heritage cinema and the *cinéma du corps*, its cultural successor, is stark and definitive. This is a major dichotomy in French film history, akin to the rupture between 1950s commercial cinema and the French New Wave. Heritage costume dramas reproduce the past; they depict national history as a shared communal memory; their film style is classical, built around the attractions of opulent production design; they solicit and charm the viewer as a complicit participant; they screen historical events as a known, fixed juncture of resonant moments in time (Matsuda, 1996, pp. 171–173). Utterly divergent, the materials of the *cinéma du corps*, as we have seen, traffic in an aggressive, lyrically brutish contemporaneity. In the *cinéma du corps* the past is dispersed, gone and unlamented; personhood and individual agency are troubled and erratic; there is no lingering implicit shared national ancestry, just an often frenzied

ongoing scramble for the precarious security of the self; no longer are there any meaningful social networks to the embattled lived here and now. Instead of a continuum from past to present, in the *cinéma du corps* there unfolds an anxious contiguous presentness, the terminus of today, a peculiar abstraction from history and a dissolved social contract. 'France' itself ends up hard to pinpoint – she is an absent presence, a vanishing nation-state that fails to preside over the activities of individuals liable to turn feral, even bestial, driven by animalistic sexual compulsions rather than a developed empathetic consciousness. And instead of unified concerted on-screen representations of legible events, perhaps most crucially, in the *cinéma du corps* we as viewers are immersed in, subtended by, avant-garde renderings of stylistic minutiae that bristle with malaise.

Straddling the new millennium, in the form of this *cinéma du corps* France contrived nothing less than a wholesale revolution within its film ecosystem. French cinema in turn emerged, ferociously energized, from a kind of creative hibernation. And the implications of the *cinéma du corps* radiate even further. This uncompromising film template attacks nothing less than the prevailing, endlessly reiterated modern cultural idiom of 'Paris' herself: as somewhere locals thrive and visitors blossom, a beacon of enlightenment, an oasis of history, a place in which the disillusioned traveller might find themselves, spiritual and/or romantic self-discovery accompanied by the material pleasures of superior fashion, wine, food, drink and lovemaking. The cunning and subversive *cinéma du corps* charter declares: reverse all this, raze it to the ground. Although Noé is an assertive individualist, an accomplished provocateur in his own right, it is from this shared palette of materials, these bravura *cinéma du corps* designs, that he gathered velocity and purpose in his course towards *Irreversible*.

✕ PART 3

GASPAR NOÉ: ALONE AGAINST EVERYTHING

There is an overriding logic to the rising profile of Gaspar Noé, primary author of, and ambassador for, *Irreversible*, this creative malcontent working within, both for and against, the contemporary French film ecosystem. The fact is that there exist many diverse Noés; as an agent of film-making, with all its avenues, Noé proliferates, multiplying before our eyes. Even in the outcomes of the actual *Irreversible* project, many different elements of Noé's varied career refract into view. There is the fierce artist brought out before probing film festival panels and interrogated by journalists in print interviews; the applied cinephile offering dense testimonials about the legitimacy of his film's conceptual citations; the diligent co-producer who finally secured financing after years of scrabbling for funding; the technically adroit director of photography and camera operator responsible for the film's flamboyant cinematography; the writer who perversely sets up dramatic tableaux backwards; the editor who scrambles images as much as assembles them; and the actor we briefly glimpse masturbating in The Rectum (in interview Noé often claimed to have made this cameo to depict himself as gay too, evading any future charges of homophobia; it's also as if, right from the start, Noé defiantly shows himself getting off on the film-making going on around him).

More broadly, in the career arc that led him to *Irreversible*'s plethora of tasks, Noé's background encompassed a growing composite of roles from a wide range of professional perspectives. Working in French media obliged and enabled Noé, in sum, to seek out continually new ways to expand his creative and logistical repertoire. Born in Buenos Aires, Argentina, on 27 December 1963, Noé was foundationally exposed to art, and non-traditional forms of mise-en-scène, from the start of his life. Noé's mother was employed as a social worker (itself a trace idiom in Noé's work), while his father is the internationally exhibited multimedia artist and painter Luis Felipe Noé, a man credited by his son with many of his artistic motivations: for deploying avant-garde designs in representational contexts; for attenuated or bizarre conceptions of human bodies; and for embracing psychedelic and psychotropic imagery in his film-making.

(The role of hybrid forms of painting is a neglected context for Noé's emergence, signaled as such in the official biography on his personal website, letempsdetruittout.net, and I will return to consider its importance in Part 7.) Travelling between New York City and Argentina during Gaspar's childhood, frequenting artistic circles, the Noé family finally abandoned South America due to its political instability, permanently relocating to Paris in 1976. Noé's education thereafter encompassed film-making, photography and cinematography (at the Louis-Lumière film school from which he graduated in 1982), and philosophy (Noé intermittently audited classes at the Université Paris 1 Panthéon-Sorbonne, right at the heart of the French educational establishment). The uncle of a friend was a film projectionist, so the teenage Noé followed the classic New Wave cineaste profile, gorging himself on films through the Parisian revival circuit: *The Lady in the Lake* (1947), *Inauguration of the Pleasure Dome* (1954), *I Am Cuba* (1964) and *2001* being the encounters Noé would refer to most often, and most reverently, in later interviews.

At this stage began one of Noé's defining early phases: to create short films, sometimes nominally for educational purposes, usually technically brash and experimental, occasionally designed to be set to music. Noé's early non-feature work relates to Conn Holohan's conception of shorts, a format which not only exists pragmatically, as calling cards of fledgling professional purpose but also artistically as elaborating an 'aesthetic of intimacy' rich with authorial fingerprints. In Holohan's view, the institutional and textual specificity of short film-making hinges upon an artful pursuit of the decisive on-screen instant: a temporally and stylistically condensed model, as 'within the short film, what is most at a premium is time, and therefore the relationship between screen time and narrative time becomes particularly charged with significance' (2010, p. 88). Much of Noé's short work pivots upon versions of Holohan's singular expressive episode, a representational linchpin moment within a cinematic palette already emerging as sexually charged, densely stylized and socially atavistic. *Tintarella di luna* (1985) is a precocious test case, made by Noé when he was

still a film student, produced on a shoestring through his first company, Les Productions Nocturnes; even as an 18-year-old novice Noé saw himself as a film-maker-by-night. Shot on 35mm, already favouring Noé's customary expansive 2.35:1 ratio, *Tintarella di luna* explores a bizarrely abstracted mise-en-scène. The short film's opening title caption situates us within a grim remote agrarian village, ravaged by plague, in which people scramble to survive. Starting in chiaroscuro black and white, *Tintarella di luna* follows a middle-aged woman, Charlotte (Cécile Ricard), brutalized by various men within her community; one yokel (played by Noé's father; the film itself is dedicated to Noé's mother) eventually strangles and kills her. The film next switches to colour and relocates to another, outsized parallel above-ground industrialized world in which a busy manual worker puts Charlotte's dead body in his shirt pocket, claiming it without comment like a grisly shrunken toy. The up-tempo title song, a cover version of the Italian diva chanteuse Mina's 1959 popular hit, then plays over the end credits. This, then, is Noé's first creative micro-statement – a diegetic snapshot of deep-seated predatory sexual urges, women encircled and aggressed by men, an oddly anti-realist world with little or no relationship to contemporary France, cheerless backwaters erupting in the heart of modern urban society, situations laced with stringent black humour.

From *Tintarella di luna* onwards, Noé's shorts refined his distinctive conceptual approach. Frequently collaborating intimately with Lucile Hadzihalilovic under the auspices of their Les Cinémas de la Zone company, Noé's early works are densely inflected collections of perceptual instants, images and sounds often set against each other, brief encounters configured by incensed carnal appetites rather than dialogue. Two Noé-infused shorts from 1998, both produced of all things for a sex education series, *A Coups sûrs*, promoting safe condom use, distil the approach. (There really is something deliciously French about this duo, Noé and Hadzihalilovic, pitching their ideas then being commissioned to ply their trade as sex educators.) Noé's output as director for *A Coups sûrs* was *Sodomites*, which stages a grotesque tableaux of bikers, before whom a

wolf-masked wrestler appears, who then applies a condom and lube and begins anal sex with a complicit recumbent woman. During their copulation, *Sodomites* accelerates into a stylistic maelstrom: long shots from overhead, big close-ups of leering onlookers and the faces of both enraptured participants, and mobile framings that career us vertiginously through space; the mise-en-scène all the while plays, clearly, like a more graphic heterosexual encore of Kenneth Anger's *Scorpio Rising* (1963). (Noé actually interviewed Anger, one of his favourite film-makers, whom he described as a creative guru, for *Interview* magazine in October 2010.) On Hadzihalilovic's contribution to the series, *Good Boys Use Condoms*, Noé worked as operator and director of photography (roles condensed into his typically laconic job title: 'Camera'). Hadzihalilovic's short depicts an unsimulated sex scene in a hotel bedroom with a man and twin sisters, building up to the slogan, apparently urgent for France to grasp, 'Change partners, change condoms'. At the point of the man's sexual climax, however, comes a by now familiar Noé amplification-disintegration tactic: in optic crescendo his camera spins independently of events on the bed to rocket around the room, reversing directions and increasing in speed; Hadzihalilovic counters its movements with a piercing, shrill, fragmented treble sound, which supplants the sounds of weirdly everyday hotel use – a ringing telephone, bells, smashing glass, snatches of distant conversation, murmurings from a television – heard previously. (An equally divisive visual-aural system would drive Noé's later short, *We Fuck Alone*, part of the *Destricted* [2006] compilation film, in which solitary sex acts are shot within stroboscopic light flashes amidst the wail of an off-screen neglected baby; Noé's snide joke being that procreation is the antithesis of these contemporary sex practices.) A carnivalesque style, this pleasure-effrontery hybridization, is obviously, for both Noé and Hadzihalilovic, the main agenda in these pilot projects.

Gaining professional momentum alongside Hadzihalilovic, Noé began to intersperse mid-feature narratives within his growing roster of shorts. Longer films meant an expanding diegetic backdrop in which to situate their charged textual instants, a canvas typified for both collaborators

as overridingly unromantic treatments of a primal France, animalistic, with only vestigial trappings of modernity. Even in cityscapes these Noé-Hadzihalilovic adult humans feel stubbornly primeval; a sense of diegetic menace subsequently rises from a young passive female protagonist placed within such desolate environments. As Matt Bailey puts it, the diegetic spaces constructed are 'more akin to the France of Victor Hugo, Émile Zola, and Henri Charrière than the bourgeois, urbane France' that is common to contemporary French cinema (2003). *La Bouche de Jean-Pierre* (1996) – a true partnership scripted, produced, directed and edited by Hadzihalilovic, and photographed, designed, co-edited and 'artistically directed' by Noé – is an especially caustic medium feature about a nine-year-old girl, Mimi (Sandra Sommartino), sent to stay in a dismal high-rise HLM apartment with her indifferent aunt and sexually abusive uncle; for want of options Mimi eventually overdoses on sleeping pills. Shot by Noé in steely widescreen long take tableaux, arrestingly shallow focused, centred upon Mimi's impassive but increasingly strained facial features, *La Bouche de Jean-Pierre* is pervaded with dislocating electronic tones, a repertoire of disjuncture and alienation. The film's bracketing devices set the agenda: Hadzihalilovic opens, with a reverberating aural crash, on the caption 'France Today'; then at the end, after Mimi's comatose face dissolves to white-out and she is hospitalized, we get two further deceptively calm post-face titles: 'Moral' (Mimi's surrogate parents decide to abandon her), then 'End'.

Showcased in *La Bouche de Jean-Pierre*, by now these anti-realist Noé-Hadzihalilovic productions were poised between grating stylistic parameters and pernicious, impressionistic, debilitating social backdrops. A defining context here, seldom applied to this pair of young film-makers, is that they are both recent immigrants to France: Hadzihalilovic is first generation French, born (in 1961) in Lyon, but of recently arrived Bosnian parents; Noé landed in Paris only when he was nearly 13. The disengaged unflinching glare of outsiders is by consequence central to their work, an unattached viewpoint provoked by a retrogressive France they see as divisive,

tribal rather than unified, socially unequal, rampant with reactionary and rapacious instincts. Towards the latter stage of Noé's emergence, in the form of the medium feature, *Carne* (1991), and continued in his debut feature, *I Stand Alone* (1998), he develops this scathing diegetic world, centred upon the figure who prefaces *Irreversible*, the Butcher, played by Noé's regular, Philippe Nahon. This Butcher – a man who handles dead flesh for a living, confused and adrift, violent, with no reliable outlet for his sexual cravings – is an iconic Noé creation. Played by Nahon as a grimly despairing ideologue, hostile to everything he sees, lumpen and callous yet ironically not immune to feelings, the Butcher is utterly set apart from modern life: French but with none of its productive social or personal assets, devoid of culture or creativity, scrabbling at the pitiless rough edges of society. In *Carne* the Butcher is jailed for murdering a co-worker he thinks, mistakenly, has molested the autistic daughter whom he cares for alone. *I Stand Alone* broadens the Butcher's narrative through backstory (he is revealed to be an orphan who was abused by a priest as a child), and then remorseless diegetic advance (after leaving jail the Butcher opens a second shop, grows to despise his life with a new lover, whom he then attacks, then flees to Paris, climactically contemplating having incestuous sex with his institutionalized daughter).

By this stage, Noé's professional portfolio was firmly established; both *Carne* and *I Stand Alone* won prizes after their Cannes premieres (the International Critics' Week award for Best Short, and the Best Feature in the Critics' Week, respectively). As Noé's actual films grew longer, moreover, so too did they deliberately merge transtextually into a single, unfolding cinematic scroll painting. Hence, *Carne* and *I Stand Alone* mutually intersect; *Irreversible* is then set off by the returning Butcher (who discloses that he did in fact have sex with his daughter); the flicker film that ends *Irreversible* bleeds into the flashing opening titles of *Enter the Void*, and so forth. Noé's auteurist ambitions are thereby made abundantly clear: his films are but one film, an expanding canvas in its creator's mind's eye. But even by the release of *I Stand Alone*, Noé's reputation

was evident thematically and conceptually. The crowning motif, perhaps, was Noé's appetite for textual disjunctions – the pre-*Irreversible* projects are ever more careful to steer the viewer away from perceiving the films to be naturalistic, or didactic, or, indeed, textually unified and consistent at all. As such the *Carne-I Stand Alone* diptych teems with an arsenal of counter-cinema tactics: non-diegetic sound eruptions (from overamplified gunshots, to cascading thumps and resounding martial electronic chords); non-diegetic interludes (like intertitles and embedded on-screen warnings about unpleasant content ahead); oscillations of shot scale (extreme long shots cut to close-ups and vice versa, as in more grotesque or baroque spaghetti westerns); and deliberately uneven deployments of freeze frames, or long takes that alternate with bursts of hasty cutting. The central motif in *I Stand Alone*, of the Butcher dourly slicing meat while captions report the passage of his wasted years, is eminently, characteristically Noé – that time proceeding imparts entropy, that all personal progress is illusory and, above all, that stylistic emissions will harass these brittle diegetic spaces at every opportunity. *Carne*'s opening segment is also representative: it takes us from a title card cautioning us about the film's looming imagery (that runs 'the risk of affecting impressionable spectators'), to kaleidoscopically overexposed shots of a horse being slaughtered and drained of blood, to a close-up of a barely cooked steak on the Butcher's table. A modern-day descendent of the slaughterhouse workers in Georges Franju's *Blood of the Beasts* (1949), Noé's Butcher lumbers through the trenches of a France seen as an endless, brutalizing, dog-eat-dog war among animals. Like Franju – whose workers at one point break into a cheerful chorus of Charles Trenet's famous 'La Mer' song while carving carcasses, prefiguring the notorious rendition of 'Singin in the Rain' set to ultraviolence in Kubrick's *A Clockwork Orange* (1971) – Noé mediates this on-screen world, its contingent array of boisterous expressive instants, with committed dispassion, cutting dark humour and unyielding stylistic rigor.

Lest Noé's professional emergence seem purely negative or attritional, however, in the face of the Butcher's ongoing miseries, there are several

other decisive productive currents to Noé's on- and off-screen creative surge in the late 1990s and early 2000s. Primary among these are Noé's encounters with Benoît Debie, the virtuoso Belgian lighting artist and director of photography, Noé and Hadzihalilovic's mainstay collaborator from *Innocence* and *Irreversible* onwards. Debie is a graduate of the Belgian L'Institut des Arts de Diffusion (Institute of Media Arts), a well-regarded veteran of television (based at one point at Canal+) who apprenticed initially in film with the Dardenne brothers on *Je Pense à vous* (1992), then as sole cinematographer on Fabrice du Welz's short, *Quand on est amoureux, c'est merveilleux*, that same year. Scouting for a visual consultant – in the customary French fashion, by viewing upcoming talents making shorts – Noé saw this latter film and telephoned Debie to ask him to collaborate on *Irreversible*. Both men in hindsight considered this to be the moment when their mature careers really began (Feuillère, 2006). Like Raoul Coutard and Henri Decaë before him, aesthetic stalwarts of the French New Wave, Debie's emergent reputation was for creative efficiency and technical skill, the ability to contrive lithe mobile frame set-ups, and penetrating luminescence with few or no artificial light sources (Levy, 2013). While Noé often brands himself an image fetishist, Debie became his pictorialist counsellor, his right-hand man.

Across his work for Noé, Hadzihalilovic and others, there clearly emerged a Debie touch; like Gregg Toland in North America or Kazuo Miyagawa in Japan, Debie is that rare cinematographer with auteurist capabilities. Debie's expressive repertoire would, moreover, supply vivid ingredients to *Irreversible*'s image track. One of Debie's main habits is to open on, or strategically highlight, an array of organic debris and/or imagistic abstractions, citing Stan Brakhage's *Mothlight* (1963), conveying avant-garde 'adventures in perception' as much as simple diegetic introductions (Palmer, 2011, pp. 172–173); this Debie motif is a remarkable lead-in to both *Innocence* and du Welz's horror film, *Vinyan* (2008). Second and more pervasively, Debie labours to make the materials, grains and glowing textures of light tangible: the ways in which it bathes a film's mise-en-scène,

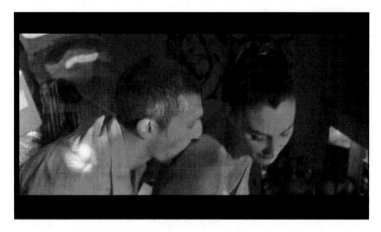

Figure 6: One of Debie's contributions, as lighting artist, to *Irreversible*: studies of light on
Alex's and Marcus's bodies during the party in segment 9

how it secretes itself in spaces through which human bodies move. The spray
of illumination itself becomes a shaping accent of Debie's style, something
to be manipulated either with colour filters or reflected sunlight rebound-
ing off walls and screens, and Debie typically favours the lush organic visual
spectrum of celluloid (notably Super 16mm), whose density can then be
augmented digitally in post-production. (Debie's design parallels Céline
Bozon's extraordinary photographic work on her brother Serge's *La France*
[2007], a 'soup-light' imagescape derived from an obsolete form of Kodak
film stock [Palmer, 2011, pp. 138–143].) We know scientifically that light
moves in waves, and study its representation attentively in paintings. But
seldom do we apprehend these light waves in cinema, as in Debie's work: the
swathe of luminescence coursing on screen, the currents of illumination that
gush in three dimensions, washing over people and things. Third, and per-
haps dominant, there is the participating role of the fluid travelling camera:
Debie is a master of the formal permutations of the human figure deployed
within a sinuous, aesthetically confining sequence shot. (Noé's own fixation

on organizing long takes was obvious from his early music videos, as on his single shots for Mano Solo's 'Je n'ais pas' [1996], and Bone Fiction's 'Insanely Cheerful' [1998].) As in Debie's extraordinary initial long take (a set-up that is also a thematic thesis) that begins Julia Loktev's *Day Night Day Night* (2006), a film about the last 48 hours of a female suicide bomber, Debie's camera tracks at length, in medium shot, a body studied in motion from the rear, lit in dazzling saturation, studying the minutiae (and possible emotional tells) of its gait and bearing, shallow focal planes rendering the backdrop indistinct; this human form becomes abstracted, hermetically sealed off from a diegetic world made unclear, dissolving, foreboding. This Debie rites-of-passage sequence shot – the French term for which is a *traveling*, which seems salient both literally and figuratively – has, as we will discover later, enormous representational significance for Alex at vital points of *Irreversible*; within Debie's collaborations elsewhere it also entirely configures the incandescent scenes of carnage at the conclusion of Harmony Korine's stylistically majestic *Spring Breakers* (2012).

One final culmination of Noé's rise – concomitant to his elevated stature in *Irreversible*'s aftermath – is his reaching a summit that is a benchmark of prestige within the contemporary French film ecosystem. This mark of distinction came, in 2006 and afterwards, through Noé's emergence as a film instructor and professional workshop leader. As such, Noé finally came to embody the French norm, discussed earlier, of established graduates, upon invitation and in quite select company, repaying their institutional debts by returning to film school, there to impart their hard-learned creative tools of the trade to the next generation. Applied cinephile students like Noé hence aspire to the status of veterans, artists in residence, masters of their craft. In this context, for the privately funded European Graduate School, based in Saas-Fee, Switzerland, a postgraduate degree-granting body specializing in media and communications, Noé represented an attractive hire. (The school's returning faculty also includes luminaries, and several *cinéma du corps* film-makers, such as Catherine Breillat, Claire Denis and Atom Egoyan; Agnès Varda is perhaps the institution's most highly regarded

French figurehead.) Thus in summer 2006, Noé returned to the classroom to convene a three-credit seminar entitled 'Tracing Film: Film and the Void'. In his new capacity as professor, Noé assigned readings (mainly of his own interviews), curated screenings (of his own films, of course) and delivered a series of lectures on film practice and theory. The school today still features all of Noé's ancillary materials, along with images and videos of his – apparently very animated – teaching, proudly on its website. Twenty-four years after graduating from L'École Nationale Supérieure Louis-Lumière in Paris, a struggling, unemployed yet ambitious artist film-maker on the make, Noé was by this new phase of his career considered to be nothing less than a leading light of French cinema, a senior statesman for European film culture, a source of inspiration for others. Whatever the debates about *Irreversible*'s controversy and value, its reception within the film trade in this way saw Noé securely enfranchised, situated in the upper echelons of French and European cinema practice, his early career valorized for all to see.

✖ P<small>ART</small> 4

NOÉ DESTROYS ALL THINGS: *IRREVERSIBLE*'S NARRATIVE AND STYLISTIC DESIGN

Gaspar Noé is often described as a nihilistic or extremist film-maker – both of these adjectives implying that he is corrosive instead of constructive, giddy or wild rather than self-disciplined. A central argument of this book, however, is that the opposite is the case. *Irreversible* is at its core a controlled, refined, conceptually and structurally *organized* creation, not an out-of-hand orchestra with discordant instruments all shrieking at once. Much as *Irreversible* can feel invasive and overpowering, incautious about destabilizing its diegetic world, this is nonetheless a work of film that is densely creative, assiduously engineered. When Noé destroys, he deconstructs norms, so as to instantiate new techniques drawn from a plethora of sources. A leading controversy about *Irreversible*, in fact, another of its sundry ironies, is that while it can unsettle its audience profoundly, the film's textual constitution is fundamentally logical, driven by its own version of order and reason. Having considered the shaping factors of the contemporary French film ecosystem, the environment whence Noé came, our attention now turns sequentially to *Irreversible*'s textual composition in closer view, to pursue this argument by examining the main engines of Noé's film: its narrative design and cinematic style. From there I will move to matters of representation and reception, but it is useful to start by analysing the core principles of *Irreversible*'s construction.

The key to *Irreversible*'s narrative is that it is inverted, an effect-cause narration. This reverse chronology model is essentially as old as pictorial storytelling itself; there's even evidence that ancient Egyptian hieroglyphics found in certain Fifth and Sixth Dynasty pyramids (from around 2350 BCE) are funerary inscriptions with 'utterances' about the afterlife designed to be scanned retrograde, backwards as well as forwards (Hill, 2010). From such originating sources, writers, playwrights and film-makers are perennially drawn to backwards chronology to represent human encounters that are on a small scale entropic and deleterious, and/or more broadly, overwhelming, potentially transcendental, but often tied to death and (self-) annihilation. A foundational modern text might be the 1934 play *Merrily We Roll Along*, a Kaufman-Hart musical biopic that stages backwards the story

of a playwright who winds up grimly alone, having sold out and alienated his friends. (A flop in its day, the play was remade by Stephen Sondheim in 1981, and has been regularly revived ever since). Among a succession of more contemporary cases, there is Philip K. Dick's novel *Counter-Clock World* (1967), a dystopian tale of a future in which time doubles back on itself, causing corpses to revive in their own graves ('old-birth'), living their new lives in reverse, eventually returning to the womb to be shattered through the act of conception. Similarly satirical is a famous sequence from Kurt Vonnegut's *Slaughterhouse-Five* (1969), a rarer instance of narration that literally goes backwards, as opposed to tableaux which internally progress, but are arranged in converse temporal order. As such, Vonnegut's protagonist, Billy Pilgrim, 'unstuck in time' by the horrors of war, in one hallucinatory sequence witnesses World War II backwards, from bullets and shells sucked out of wounded bodies, to bombs being dismantled, their mineral components safely hidden back in the ground so as never to cause harm again. Related cases, other acclaimed inverted fictional accounts of trauma are: Harold Pinter's play *Betrayal* (1978; adapted for the screen five years later), about a quartet of intersecting lives hinging upon a ruinous extramarital affair; Martin Amis's novel *Time's Arrow* (1991), whose erratic implied author textually relays the life of a rejuvenating doctor, from his benign contemporary American medical practice to his younger days in an Auschwitz death camp; and Julia Alvarez's *How the García Girls Lost Their Accents* (1991), following, over 15 chapters, 30 years in the lives of four sisters, starting with their lives as uneasy immigrants in New York City, ending with their turbulent childhoods under dictatorship in the Dominican Republic in the 1950s and 1960s.

Around the time of *Irreversible*'s inception, a number of international film-makers adopted this inverted narration model, again drawn to its suitability for refracted ordeals, inexorably unravelling disasters either personal or political. Track the ripples inwards, the model mandates, then step-by-backwards-step approach the act of precipitating violence, the jagged rock first thrown in the water. A success on the film festival circuit,

Lee Chang-Dong's South Korean production *Peppermint Candy* (1999) starts with a group of friends at their reunion; when one man kills himself by jumping under a train, successive segments, retreating into the past, motivate this abrupt suicide retrogressively in the face of debilitating Korean political history. Christopher Nolan's *Memento* (2000) was even more of a cause célèbre, a regressing narrative about a man robbed of short-term memory, hunting the man he thinks murdered his wife, unaware that he is being manipulated all the while. We have already encountered François Ozon's *5x2* in the context of the *cinéma du corps*; Ozon cited Jane Campion's *Two Friends* (1986), a relationship study in reverse, as inspiration for his format. Yet certainly as Noé conceived *Irreversible* the finish-to-start approach had entered the global pop culture media lexicon anew: a 1989 television episode of *Red Dwarf* (abnormally for inverted narratives, a comedy) took place on a rewinding Earth in which people are paid money to regurgitate food in cafés, and repair a bar by reverse-brawling; there was a 2000 *X-Files* episode called 'Redrum', in which a man lives five days backwards to discover himself implicated in his wife's killing; an *ER* story, 'Hindsight', in 2002, based upon the rearward perceptions of a disoriented hospital patient with a serious head injury; and one especially celebrated sequence in Michel Gondry's *Eternal Sunshine of the Spotless Mind* (2004) during which its hapless protagonist's memories are erased, resetting him to a false emotional naiveté (Jameson, 2011).

In terms of *Irreversible*, the backwards narration undergirds a world of ironic mathematics, effects witnessed on a large and often violent scale, the causes for which are rendered disproportionately trivial, routinely buried or offset as brief asides during densely flowing scenes of diegetic bustle. A vital context is that *Irreversible* began life as a three-page treatment, written by Noé over seven weeks, which merely staked out the film's 13 segments along with 20 lines of shaping dialogue. Everything else was elaborated through Noé's discussions with the actors and crew before and as the cameras rolled; the entire *Irreversible* shoot was condensed, pressed for time, completed between 15 July and 30 August 2001, accelerated because of Monica

Bellucci's contractual commitment to film *The Matrix Reloaded* (2003) that September in Australia (Torreo, 2003). Part of the film's complexity, moreover, is that while *Irreversible* functions one way via this inverted flow – see an action or its aftermath; hunt to discern its motivating source – it also works, bizarrely, forwards too, through its actual sequential design, proceeding from start to finish. As we will analyse later via its central couple, Noé's film thereby becomes a quite moving about-face romance about two broken people reclaiming each other; it propels us from initial dissolution and despair to scenes of elation. There is even a radically atypical, fragile happy ending that catapults us into the sky.

A series of triggers underlie *Irreversible*'s effect-cause system. The film essentially is propelled by a complex of reverse-pointing cues, a flotsam and jetsam of narrative debris being swirled backwards, unstoppably sucking us down the plughole. The shaping source which dovetails here, cited on-screen by Alex, is the book we see her reading among Noé's final representational images in segment 13, *An Experiment in Time*, published in 1927 by Irish aeronautical engineer, J. W. Dunne. (Like *The Tibetan Book of the Dead*, which is featured in *Enter the Void*, Noé's narratives are at once viscerally

Figure 7: Alex reads *An Experiment in Time* near the end of segment 13

physically literal yet also cerebral, informed by quasi-mystical teachings.) Never canonical, Dunne's book has the reputation as an outlier text of almost-science that has attracted many adherents; it is sometimes cited as a parallel idiom to the Dreamtime concept of Australian Aborigines, as well as certain Eastern philosophical traditions like Taoism. Dunne's cited aim in his book was, at the outset, to record a catalogue of his dreams, which he was convinced were liable to come true, an inverse of déjà vu, as it were. Although his findings proved inconclusive, Dunne nonetheless argues in summary that alongside Time 1, meaning the temporally ensuing world we inhabit each day, there is a concurrent state, Time 2, in which all events coalesce in perpetual flux, a condition the limited human mind might access through dreams, trances and hypnotic episodes. It is to this latter state – of a perceptually aware yet offset consciousness, a waking dreamer pushed by expressive suggestion to experience time in multiple concomitant conditions – that Noé, in many interviews, argued he wanted to take *Irreversible*'s more attentive viewers (Sterritt, 2007, p. 308). Rare indeed is the film-maker bent on creating nothing less than an entire altered mode of consciousness for his audience. Many of Noé's less sympathetic respondents react, perhaps, against their perception of the passive submission implied by such a text-viewer relationship.

In concrete terms, *Irreversible*'s effect-cause narrative builds from artful offset coincidences, muffled echoes, distant points of confluence and congruence. Like the celebrated tragedies of Japanese film-maker Kenji Mizoguchi, in films like *Sansho the Bailiff* (1954) and *The Life of Oharu* (1952), Noé's film traces backwards a solitary action or deed, from which all the unfolding calamities ensue: *Irreversible* is a line of dominoes falling in reverse. The overarching primary thread is the mutating constitution and cause of Alex's rape. This trajectory – the subjugation of one human by another's will to power – starts out in broad terms as a philosophical rumination upon mankind's essentially wanton sexual depravity (segments 1–2). It then gets recast progressively in ever more specific variations: as a need to penetrate a particular space, The Rectum (segments 3–4); a crime

that has been committed by Le Tenia, an individual (segment 5); a prompt for vigilante retribution linked to a different individual, Guillermo Nuñez (segment 6); the result of there being no taxis for Alex's homeward passage, leading to her taking bad advice and going into a particular underpass described as safe (segment 8; *Irreversible*'s gallows humour is never more poisonous than it is here); the fault of Marcus for leaving Alex unattended and driving her in frustration out of a party, alone (segment 9); the fault of the hedonistic Marcus, further established, because he takes drugs that will distract him from his partner's safety (segment 10); the fault, on Dunne's terms in *An Experiment in Time*, of both Marcus and Alex for failing to heed her premonition dream about impending danger in a red tunnel (segment 11). The final originating source of all *Irreversible*'s tribulations, receding like an upside-down rainbow forever atop the next hill, comes in segment 11, relayed in the most banal, seemingly inconsequential terms: the self-pitying voice of Pierre, leaving Alex an answering machine message, lamenting the breakdown of his car, which will now force them that evening to take the Metro instead. Even further beyond this piece of trivial chance, like a classic Dunne exponential loop, we might speculate that it is the taxi ride *after* the Metro that will prove fatal, then the decision to go to the party in the first place, and endlessly after that, and so forth.

Dispersed alongside and around this central (diminishing) narrative strand, Alex's route to ruin, is a suite of intersecting lines or deeds: forth-and-backs, ironic reiterations and repetitions. Sometimes Noé interlinks particular characters and situations. We might, for example, trace Le Tenia's raping Alex to Pierre dolefully confessing that his most intense lovemaking with the same woman also ended with blood gushing from a head wound, when Alex accidentally banged herself on their nightstand. Le Tenia's hideous physical appreciations of Alex, before and during the rape, also rhyme with Marcus's similarly excited descriptions when he joins her on the dance floor in segment 9. Occasionally more specific, *Irreversible* will also pair up gestures or poses: Marcus's right arm going to sleep when he wakes from a nap, the same arm that is broken in The Rectum; or Marcus spitting

on Alex playfully in bed, versus Le Tenia's similar act of violent contempt below ground (to her lover, Alex responds, 'If you hurt me, you'll pay!'); or similar conditions of repose, like Marcus and Alex lying in bed, versus their lying unconscious on stretchers.

Moment by moment and segment by segment, *Irreversible*'s narrative structure is deceptively dense: the film disperses information like a hall of reflecting mirrors; its tone of narration, itself a binary dualism, switches from sardonic to elegiac and back again. Interpreting from this ritualistic matching process, Douglas Keesey argues that Noé's narrative design amounts to an undergirding critical logic about masculinity. In this train of thought, given that Marcus and Pierre mimic Le Tenia so consistently – Pierre destroys a man's face as Le Tenia does Alex's; Marcus and Le Tenia get high by snorting drugs (cocaine versus poppers); both men assault a woman in an underpass (Concha; Alex) – *Irreversible* ultimately reveals 'the avenger [to be] the rapist's double...[his] revenge is part of the same masculinist ideology that led to the rape, a myth of male inviolability perpetuated through the violation of others' (2010, p. 99). Keesey's account is convincing, but there is other mitigating evidence about Marcus for us to consider later, especially from the last crucial half of the film, which most respondents do strategically tend to overlook.

The final point to make about *Irreversible*'s narrative is that its endless internal echoes also have external counterparts; Noé's cunningly designed diegesis abounds with intertextual resonance, a tissue of sometimes unexpected citations. The most overt line of influence is the so-called rape-revenge film, whose ancestry extends from the exalted (Ingmar Bergman's seminal arthouse film about God's silence in the face of atrocity, *The Virgin Spring* [1960]) to the critically despised exploitation movie (*I Spit on Your Grave* [aka *The Day of the Woman*, 1978]). Noé's linchpin adjustment, though, is to remove the loadbearing crux of such films: the climactic grisly punishment of the woman's actual assailant/s, hence the concomitant assessment of whether the initial crime justifies its horrific retribution, be it by the actual victim herself (*I Spit on Your Grave*) or her

avenging parents (*The Virgin Spring*, *The Last House on the Left* [1972]). Not only is *Irreversible*'s justice meted out in The Rectum by Pierre to the wrong person, with an amused Le Tenia looking on, almost like a director on set, but we begin with the rape's violent aftermath, making it, by consequence, a grotesquely offset or refracted call to arms. (We will return to the actual representation of Alex's rape in detail later.) In sum, then, again Noé puts the cart before the horse – *Irreversible* becomes a revenge-rape film, a study of disproportionate energy unleashed, compromised justice endlessly mismatched to actual circumstances.

The intertextual aspects of *Irreversible*'s narrative continue, however. The film's main narrative passage (segments 1–11) relates formally to another historical continuum of world cinema: continuous real-time or compressed duration films. This format typically derives suspense by conflating a limited amount of time passing on screen (usually underlined via long take sequence shots) with an uncertain resolution to a serious crime either pending or past: *Rope* (1948; murder), *High Noon* (1952; murder), *Nick of Time* (1985; kidnapping), *Tape* (2001; rape). From Noé's advanced applied cinephilia also comes a third point of influence, more conjectural but nevertheless intriguing – *Irreversible* as a distant cousin to *Bicycle Thieves* (1948), a film perennially on the curricula of Parisian film schools like L'Institut des Hautes Études Cinématographiques. Consider that both Vittorio De Sica and Noé instantiate an arbitrary yet life-defining crime within the course of an initially blithe male protagonist, an act with no hope of direct restitution in a diegetic world whose social contract has declined (post-war Rome versus *cinéma du corps* Paris), charting through this male protagonist's desperation the depths to which an essentially ordinary man will be driven, what crimes he himself will commit to – in vain – restore what has been lost. And both *Irreversible* and *Bicycle Thieves* offer no solutions; they leave their failed protagonists adrift and in the abyss. However, whereas in the face of such a hostile world Ricci (Lamberto Maggiorani) at least has the succour of his son's proffered hand, Marcus's child, unbeknownst to him, has already likely been taken from him. The

upshot of *Irreversible*'s entire matrix of narrative designs, though, might merge into a single unswerving cautionary note. Never cease to be careful with what you consider to be yours, Noé opines, treasure always the assets of your life, because time in abstraction may destroy all things, but on a person-by-person basis it robs, it cheats, it rapes and it murders.

Permeating the events of *Irreversible*'s narrative is their on-screen deployment through visual and aural cinematic style. Yet while the film's diegetic deeds tend to be overt and emphatic, violently or passionately carried out, the formal means by which they are conveyed is often by contrast elliptical, evasive, disturbingly recondite. Neither the soundtrack nor the imagetrack remains stable, or in unison, for long. Noé defines this template at greatest length in segment 1, which exists, as much as its diegetic actions (the Nahon character's cynical preamble; Marcus and Pierre being ejected from The Rectum) as a conceptual preface, establishing the film's stylistic premise. Part of Noé's means are technological: *Irreversible* was shot with, and in real terms configured by, a lightweight Minima Super-16mm camera, billed at the time through its vendors as the lightest and most ergonomic film camera on the market. Parameters of optical mobility and exploration, by consequence, are at the outset *Irreversible*'s goals. Intersecting with but not wholly bound to conveying diegetic events, Noé's self-operated camera simply negotiates and navigates space, collating visual data, while tremors of unmatched sounds accrue. The captured images summon light, shade and texture; racked focal planes alternate as our visual perspective recedes and advances; the camera's vantage point rotates in a series of wandering spatial circuits; the frame propels us through zones of darkness punctuated with arcing flashes of light (man-made sources: neon and fluorescent), lens flares and shards of sharp colour. Aurally we hear minor-key strings competing with an underlying bass rumble and scraps of static noise; a tinny rising high-pitched whine, designed to make our ears recoil and our faces wince, completes the sound mix. Briefly Nahon's voice rises to prominence in this topsy-turvy sound hierarchy, but the human voice will not be privileged like this again until after segment 2, more than 20 minutes

later. Partly this opening orchestration could be recuperated as a (highly inefficient) establishing shot: an extensive navigation of the mise-en-scène of this dismal neighbourhood, a defamiliarized marginal Paris, an uneven equivalent to the customary track-ins onto ageing tenements that open classical poetic realist films like René Clair's *Under the Roofs of Paris* (1930). Or, alternately, we might interpret Noé's roving and darting camera to lend, like the initiating crane shot of *Psycho*, a wilful tonal pessimism to what ensues—as if the choice of final situation, *that* room or *this* street, matters little to the disreputable human activities that will inevitably be uncovered.

The real point, though, to Noé's kinetic staging is that *Irreversible* wants formally to declare its avant-garde stylistic aspirations up front. The composite of film style itself, sound plus image, so often relegated to the status of invisibility, a mere container for events on-screen, a functional tool from which drama builds, here asserts itself pugnaciously, its right to be noticed, to mediate *Irreversible*'s surveillance. Diegetic omniscience dissolves: *Irreversible*'s viewers are left to fend for themselves, to ponder

Figure 8: The practices of North American avant-garde film-makers Hollis Frampton and Michael Snow revived in *Irreversible*: Canted mobile framings charting sectors of space around the tenement mise-en-scène of segment 1

strictures of cinematic technique as much as, or more than, a coherent arena of action carved up for our appreciation. Protracted initially, then a punctuating insert device between the segments that run the film's full length, Noé's aesthetic motifs here also merge avant-garde structuralism with the flicker film; *Irreversible* maps out a continuum of avant-garde practice, engaging with twenty-first century technologies the work of experimental film-makers such as Hollis Frampton, Paul Sharits, Tony Conrad and, decisively, Michael Snow. Agile, fleet and nimble, Noé's camera work isolates particular formal properties, emphasizing the vertical and horizontal axes of space, then a 360-degree orbit, forwards and backwards. These are the trails that Noé's extraordinary camera is able to transcribe, accompanied but not complemented by *Irreversible*'s sound samples. Crisp focal planes jostle concomitantly with unfocused swathes of graphic visual data; aural timbres and soundtrack commotions reverberate, rising and falling. The diegetic world here, such as it is, becomes dissimulated, broken down into components of visual and aural information, a space inhabited and mastered by forceful technologies, in which people, however violent, do not dominate.

Noé's design, in sum, deploys a conception of Frampton's, who describes his work in *Ordinary Matter* (1972) as a parallel to Snow's spinning camera machine in *La Région centrale* (1971); the shared paradigm might equally apply to Snow's more famous study of the zoom lens in *Wavelength* (1967). The execution, this matter of the film itself, thereby according to Frampton 'presents a deanthropomorphized vision, by traversing the space in a manner and at a speed that a human being could not' (Sitney, 2008, p. 118). Regardless to, and offsetting of, human agency, *Irreversible*'s cinematic schema is to study cinematic velocity itself, the technical and optical means through which the on-screen world turns, and is relayed to us, the viewer, as all the while sound competes, colliding with these images, and us. Annette Michelson's famous 1971 study, 'Toward Snow', offers via an analysis of Snow's *One Second in Montreal* (1969) an observation that also applies variously to *Irreversible*. Noé's camera, like

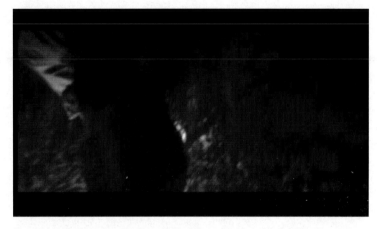

Figure 9: Noé's cinematography flirts with illegibility and problematizes the viewer's vantage point: Marcus, glimpsed upside down, within the kinetic style of segment 2

Snow's, delivers a panoply that frames an abstract cinematic consciousness: as Michelson puts it, 'an inquiry into the modes of seeing, recording, selecting, composing, remembering and projecting' (1971, p. 183). This sound-image system is never more overbearing than in segments 1 and 2, but its after-echoes linger on. We can never quite forget that our viewing position in *Irreversible* is precarious, that this diegetic world might at any moment disintegrate again.

Noé's forward momentum, *Irreversible*'s further estranging hybridity, is to take this paradigm and then apply it to diegetic spaces occupied by people in escalating states of agitation. This is a troubling stylistic oxymoron: avant-garde abstraction as a mode of discourse fusing with film's more typical imperative to depict human interactions; a camera with the capacity to assert itself independently that then immerses itself within stagings of aroused corporeal conditions. Taking us down into the nightclub below, Noé's camera also engages another long-standing formal dimension of film – its ability to preserve temporal unities, apparently or actually, recalibrating the properties associated with the long take or sequence shot. As it progresses,

Irreversible's style makes a sly point too about the traditional organic versus the digital. Whereas Snow had painstakingly to build a pre-programmed robotic arm to make *La Région centrale*, or a complicated gyroscope for *Back and Forth* (1969), Noé's digitally compatible camera confers the ability to permeate space seemingly at will – in the air, underground, through The Rectum's walls – while composite editing (Super 16mm celluloid transferred to computer, thence to a 35mm final print) fuses the resulting swirls into a deceptive impossible whole that compels yet bewilders any viewer seeking unity (Willis, 2003, p. 9). The long take/deep space stylistic system, once prized by André Bazin for its seamless truthful distillation of the real world, turns now in *Irreversible*'s segment 2 into a disharmonious and duplicitous – yet consistent and constant – array of glaring sensations. The Bazinian long take, classically conceived as authentic and empowering to the viewer's scanning eye, mutates here into a digitally arbitrated set of fused, confusing abstractions. Rather than opening up complex but legible axes of action (most famously through deep focused images in William Wyler's *The Best Years of Our Lives* [1946]), in *Irreversible* we get faked organic fragments: sexually agitated men relayed as a hostile chorus of glimpsed tableaux, heads and body parts plus delirious moans, sequentially building to a traditional long take crescendo that shows Pierre taking a man's life, another digitally augmented set-up during which actual flesh, a face and a skull, is shown falsely (via post-production digital superimpositions) to be destroyed directly before the camera's field of view.

At *Irreversible*'s outset, then, our analysis of narrative and style dovetails to reveal this model of relentless, ingenious incongruity. In its opening minutes *Irreversible* initiates a cinematography system so powerful as to assert itself separately from diegetic events, added to which is a profoundly intrusive, non-organic soundtrack that in segment 2 climaxes with an electronic bass drone emanating at 27 hertz, a frequency that has been used by the French police to induce nausea and disperse threatening crowds (Palmer, 2011, pp. 74–75). Cinema, according to Noé, therefore discharges and erupts; it outstrips functionality. Style instantiates narrative

only by chafing, by creating friction and tension. We are a rioting mob; Noé is the riot police. Like an apparently out-of-hand fireworks display or a diegetic bout whose referee encourages and urges dissention, Noé's sound-image composite invades and escalates proceedings. This is a scheme that will then be marshalled to facilitate, and sometimes intensify, excesses of human behaviour within scenes that unfold in order, backwards. Consequently, *Irreversible*'s design is so strategically divisive that it threatens to dissolve into outright chaos: the film short-circuits, it doesn't compute. This is, after all, a counter-cultural underground film with major stars (as if *Meshes of the Afternoon* [1943] were recast by Maya Deren to feature Cary Grant and Ingrid Bergman); a logistically demanding medium-budget (by French standards) film shot in just 46 days; a dense piece of narrative contrived from wisps of scripted suggestions; a film intent on distinguishing the abstract formal properties of film (with digital asides) that also recounts viscerally attenuated human activities. Wherever you look and whatever you hear, factors of design themselves intrude upon *Irreversible*'s diegesis as much as symptoms of human agency. Style itself becomes an inexorable agent on its own terms, like the forces of temporal predestination we are led to believe dictate the lives of buffeted people like Marcus, Pierre and Alex. In *Irreversible* the parameters of cinema profoundly convene, but they also attack and disrupt.

✕ Part 5

CASSEL, BELLUCCI, DUPONTEL: *IRREVERSIBLE* AS ROGUE STAR VEHICLE

From its inception, French cinema, sustained during its many historical reorganizations, has always privileged a constellation of film stars, especially in its contemporary phase. Although never as industrially regimented as the heavily capitalized Hollywood studios, with their calculated economic manufacture of star-personalities, France nonetheless, as Ginette Vincendeau describes, 'has a star system by virtue of the number of major film stars in activity, the length of their filmographies and the discursive production that exists around them: press, radio and television coverage, award ceremonies (the Césars) and festivals, especially Cannes' (2000, p. 1). Equally alert to Cannes as a linchpin site, as well as France's gallery of attending celebrity magazines, Guy Austin confirms the importance of stars to maintaining the French cinematic status quo. Especially after the 1960s, and the large-scale commercial augmentation of the French film industry in part through star-producers inflating their status as cultural commodities, Austin suggests the extent to which effectively 'French cinema has seen the triumph of a Hollywood-style star system' (2003, p. 6).

Stardom in French culture has its own local permutations, though, which can be traced through their linguistic ancestry. There is since the 1920s the French use of the anglicized word *star* itself, alongside *étoile* (an actual heavenly body, used mostly in classical music, ballet and the circus) and *vedette* (a more common tag attached to a famous and high-profile person, often figuratively via their top theatrical or cinematic billing). Unique to France, however, is the term *monstre sacré*, literally meaning sacred monster, a historical term (of classical origins, referring to half-human, half-animal creatures such as sphinxes and minotaurs), revived in the nineteenth-century Paris theatre circuit and applied to its most hysterically emotive divas, which also crossed over into cinema by the 1920s. *Monstres sacrés* and *vedettes* are occasionally used to describe the same star-performer: Vincendeau offers the example of Jean Marais, whose 1998 obituary in *Le Parisien* hailed him as 'The Last Monstre Sacré' (Vincendeau, 2000, p. 3). But the *monstre sacré* notion usually pertains to French cinema's gallery of more grotesque, exaggerated, idiosyncratically expressive, physically

distinctive and non-traditional leading performers. No *jeune premiers* or matinée idols here, but rather, in Colin Crisp's account, notoriously wayward upper-tier character actors around whom entire productions would strategically be built, archetypal cases being the likes of Michel Simon in *Boudu Saved from Drowning* (1932), and Erich von Stroheim in *Grand Illusion* (1937) (Crisp, 2003, pp. 360–361).

Prompted by our introductory visit to *Irreversible*'s Cannes premiere, which began as a splendid public tableau of its famous cast, this section will now analyse Gaspar Noé's film through one of its most neglected, yet vital, components – its use of stars, iconic *vedettes* and *monstres sacrés* alike. This was, after all, Noé's first sustained professional interaction with film stars; his discovery of their on- and off-screen powers was an acute creative encounter. In fact, from its packaged financing to its mode of production, from its publicity to its reception, *Irreversible* relied upon film stars as its most essential assets. Diegetically, moreover, *Irreversible* is an absorbing, subversive, arguably clandestine, but quite brilliant star vehicle. Right from its title sequence, which crescendoes with its main cast members' iconic last names simultaneously flashed before and drummed into the heads of the audience, *Irreversible* is configured by the signifying capacities of three of French cinema's most charismatic screen personalities: Vincent Cassel, Monica Bellucci and Albert Dupontel. In a film that discards most classical character formulations, *Irreversible*'s motor is this trio: the disturbing permutations it makes of their star profiles, the unnerving proclivities it extends to their highly recognizable bodies, the convolutions it presents of their lives as celebrities. Cassel, especially, is a riveting contemporary *monstre sacré* at the core of *Irreversible*'s expressive regime.

Although fundamental to most types of cinema, many analyses of stars and star performance can be slippery, indistinct, devolving into what James Naremore, in his classic study *Acting in the Cinema*, calls 'fuzzy, adjectival language' (1988, p. 6). My methodology, henceforth, uses a three-fold vantage point, derived from classical Hollywood, which nonetheless obtains within French cinema (Palmer, 2008, pp. 43–57). The first aspect

to consider is stars in terms of their *pretextual* qualities. This is the star as a purely physical entity, divorced from actual roles – a uniquely idiosyncratic body to be harnessed for dramatic effect, a repertoire of corporeal attributes, a quirky instrument to be played to its most rousing potential. When critics seize upon Bette Davis's comparatively enormous eyes, James Stewart's flipper-like hands, James Cagney's pugnaciously compact strut, Arletty's earthy nasal twang or Jean Gabin's rumbling mid-bass drawl, it is to pretextual elements that they attend. Second and dominant is a star's *textual* form. This is the dynamic of a performer encased on-screen within a particular cinematic paradigm: their face made-up and lit, their body costumed and blocked before cameras, their voice recorded and manipulated, their character scripted (or not); the composite, in sum, of stylistic elements trained on a star by a film-maker in pursuit of representational goals. Lastly, there is the star's *extratextual* presence. This third element derives from a star's surrounding off-screen existence: of past roles and a star persona, their ongoing promotional profile, their documented (and often highlighted) activities in actual life as they connect to and permeate, whether accurately or not, their many lives on-screen. Tracing these strands through the input of Cassel, Bellucci and Dupontel underlines just how alive and alert *Irreversible* is to its star-performers.

However you reckon the possibilities of stardom in French cinema, Vincent Cassel is a rewarding case study. Cassel is one of France's most stirring screen performers since Gabin, versatile in multiple languages (he has acted in English, French, Portuguese, Italian and Russian, the latter spoken phonetically), flitting nimbly between popular and arthouse productions, with an affinity for polymorphously perverse figures lurking in a grey area between righteous heroic and baffling horrific (Palmer, 2011, pp. 99–106). Trained as a circus performer, then debuting in television work (as is common in France) in the late 1980s, on the big screen Cassel forged a relationship with Mathieu Kassovitz that jump-started his career, from *Café au lait* (1993) to *La Haine*, in which, as Vinz, a star was born. Between *La Haine* in 1995 and 2014, the year after his amicable separation from

Bellucci, Cassel made 48 films, two or three per year, reliably sought after
by film-makers around the world. Pretextually Cassel is a disconcerting
proposition: tall at an inch over six feet, lean and sinewy in his torso, taut
and kinetic all over, startlingly feline with a marked triangular face; Cassel's
long flat boxer's nose, protruding ears and deep-set eyes accentuate volatile
features apt to shift from glee to rage and back again. Jouncing on the
balls of his feet like Cagney in his early 1930s Warners Bros.' star vehicles,
twitching in staccato motion, Cassel's body is an overheating engine, a
pressure cooker about to burst. Textually the Cassel dynamic was set in the
infamous 'You talkin' to me?' bathroom mirror routine, citing *Taxi Driver*'s
(1976) delusional vigilante, Travis Bickle (Robert de Niro), in *La Haine*.
At home with Vinz, we therein see Cassel effortlessly fluctuate between
beguiling and psychotic, a violent prankster, forehead and face contorting
in cartoonish temper; violent retributions for imagined wrongs are never
far from the surface of this ingratiating lunatic. Extratextually, Cassel's
persona, alongside his romance with Bellucci, on- and off-screen, as star and
latterly as star producer, has encompassed both sinister obsessive grotesques
(*Brotherhood of the Wolf*, *Sheitan* [2006], *Eastern Promises* [2007], *Black Swan*
[2010]) and romantic down-and-outs (*L'Appartement* [1996], *Read My
Lips* [2001], *Blueberry*). But Cassel's most powerful creations occupy both
margins of this textual spectrum, earnest passions that morph into madness,
or the reverse, in the course of a single role. Hence Cassel is a devout
religious ascetic who becomes a sexual predator in *The Monk* (2011); an
idealistic but unbalanced hedonistic gangster kingpin in the *Mesrine* biopic
diptych (2008), for which Cassel won a Best Actor César; or, in what might
just be the ultimate Cassel vehicle, the grandiloquent lead in Gans's 2014
Beauty and the Beast revival. Cassel has called *Irreversible* the single most
important film of his career, his calling card, seen by everyone who matters
in the business, his 'international passport' (Delorme, 2009, p. 24). Besides
Irreversible, though, Cassel's star complex could be condensed into a single
shot, near the end of *Trance* (2013), a bizarre film flavoured by *Irreversible*'s
flotsam (at one point Cassel's character is even bludgeoned with a fire

extinguisher), in which a CGI-disfigured Cassel, his head half-destroyed by a close-range gunshot, rears back into shot to berate calmly, almost mournfully, his assailant for having misconstrued events. Even when Cassel is brutally dead, no audience can predict the behaviour of this bewitchingly bipolar performer.

Next to Cassel in *Irreversible* is Bellucci, who is, along with Marion Cotillard and Audrey Tautou, arguably modern French cinema's highest profile female lead. Born in Italy, a fashion model since the age of 13, an international film star after a series of walk-on roles in early 1990s films like *Bram Stoker's Dracula* (1992), Bellucci has acted in Italian, French and English, famed and promoted for her pretextual form as a full-figured, passionate European screen goddess. A key motif of her textual situation, as an exotic statuesque madonna (who indeed played Mary Magdalene in *The Passion of the Christ* [2004]), is Bellucci's inhabiting an extended enticing sequence shot, on physical display, arresting the camera and bringing the surrounding narrative to a halt. Bellucci's roles sometimes invoke the putative psychoanalytical formulation of women's to-be-looked-at status in classical cinema, as stunning objects, passive prompts to masculine possessiveness, but Bellucci in her mature career phase usually retains at least vestigial screen agency over her character's destiny. As Bellucci argued in one interview, like Ava Gardner she seduces by making the camera her accomplice: 'I am a woman proud to be a woman with no shame at being desired' (Lavoignat, 2005, p. 65). One culmination of this, a major pivot in *Irreversible*, is Bellucci's textual refrain of carrying out slow, languorous, enticing dance performances on-screen; Philippe Garrel's convoluted romance *A Burning Hot Summer* (2011) showcases Bellucci this way in a sinuous, gliding prowl, set to music, a corporeal ode that lasts over four minutes. The key to Bellucci's stardom, however, both textually and extratextually, is her on- and off-screen marriage to Cassel, from 1996's *L'Appartement* (on the set of which they met, Bellucci receiving for her work a César nomination for Best Supporting Actress), through seven further pairings: *Embrasse-moi, Pasqualino!* (1996), *Dobermann* (1997), *Le Plaisir,*

Méditerranées (1999), *Brotherhood of the Wolf*, *Irreversible* and *Secret Agents* (2004). In this cycle, Cassel and Bellucci endlessly romantically sparred, shifting roles from degenerate aristocrats to undercover spies, courting in the past and in the present, until their 2013 divorce articulating a parade of romantic screen duels. So central was this star partnership to European cinema that when in 2002 *Le Film français* confirmed *Irreversible*'s official invitation to Cannes, it led with the simple headline: 'Le Couple Bellucci–Cassel' (Busca, 2002, p. 55).

Foil to Cassel and Bellucci's off-and-on duet in *Irreversible* is Albert Dupontel, much less well known internationally, but nonetheless a decisive contributor to Noé's treatments. After abandoning a fledgling career in medicine, Dupontel's career developed through his cantankerous, knockabout stand-up comedy stylings. He worked onstage in one-man routines that frequently targeted the audience with discomfiting rants (Dupontel's Paris-based run, in *Sale spectacle*, between 1990 and 1992, won him admiring notices), in television (such as a raucous Canal+ sketch series, *Sales histoires* [1990]), and eventually in film. Pretextually chiselled and craggy in appearance, lined heavily around his eyes, irritably intense in his mannerisms, Dupontel's arrested adolescence (in one popular *Sales histoires* skit he played a frantic yet misdirected teenager revising for his philosophy exam) propelled him, as actor–director, textually towards what Michael describes as 'an authorial voice between the juvenile and the satirical ... [in] stylized worlds befitting the mania of these early stage characters' (2013, pp. 23). In *Bernie* (1995), a breakout hit that won Dupontel a César (although in keeping with his textual habits and extratextual persona as an antisocial misfit, Dupontel usually shuns awards ceremonies), he played its eponymous anti-hero, a neurotic child-man orphan, utterly disconnected from reality, who rouses himself to enter Paris in a buffoonish quest for his parents. Over three follow-ups, *The Creator* (1998), *Locked Out* (2006) and *The Villain* (2009), Dupontel nuanced his largely anti-realist performance mode in increasingly exaggerated diegetic contexts; his work is frequently likened to a live-action cartoon. Even in work for other directors, Dupontel

is recurrently cast as an other-worldly outsider, taken to a kind of limit by starring as the venomous incensed embodiment of Jean Dujardin's cancer in Bertrand Blier's *The Clink of Ice* (2010). If Cassel and Bellucci, for all their performative excesses, are the backbone, the dramatic core of *Irreversible*, Dupontel is Noé's wild card. For those attuned to Dupontel's career, especially his rampaging turn in *Locked Out*, the moment in *Irreversible* when Pierre finally deals with overwhelming stress by lashing out in a murderous tantrum, destroying Marcus's assailant with a fire extinguisher, is, ironically, not that beyond the pale.

An underlying argument of this book is that *Irreversible*, despite its intermittently inflamed materials, is a fascinatingly considered piece of cinema – Noé's witty use of these three idiosyncratic stars provides yet more evidence for the measured nature of his work. Look at, for instance, the way *Irreversible* introduces its principal trio of actors. The enduring, typical device is the classical star entrance, in which pretextual and extratextual qualities are brought to bear decisively, quickly, upon a star-character's textual instantiation. First impressions last, the pop-psychology term for this being the primacy effect, the rationale that human cognition disproportionately favours initial stimuli in making longer term judgments about personality and situation. The rigorous craft of studio-era Hollywood soon made this de rigueur; many of its star entrances became justly famous. There is the introduction of Rick (Bogart) in *Casablanca*: talked up as a pensive loner American by multiple supporting characters, alone because he never sits with customers; first shown playing chess against himself, in white tuxedo, drinking liquor in the daytime, signing a cheque with a flourish as Café Américain boss; there then comes a swift tilt up to disclose a medium shot of the characteristically scathing Bogart features. Or take Rita Hayworth's even more densely rendered star entrance in *Gilda* (1946), homaged with affection decades later in *The Shawshank Redemption* (1994). Textually the Hayworth-Gilda composite is instantly organized: she is a bewitching siren first heard humming 'Put the Blame on Mame' off-screen, introduced by her adoring husband to her immediately infatuated swain; asked, 'Are you decent?'; and then we see Hayworth erupting into frame from

underneath the camera, tossing back her famous red coiffure bouquet in close-up, beaming impishly: 'Me?'

Self-respecting French film-makers, classical and contemporary, inevitably made these habits their own; many added local flavours. French film style, both past and present, is generally more unruly than its Hollywood counterpart anyway, so adopting the star entrance concept – stacking the textual deck in favour of your prize on-screen asset, presenting your star up front at their most cinematically rampant – became widespread practice in France. One recent test case, close to Noé, is Kassovitz's uproarious star entrance (more protracted than those of the other major characters) for Cassel, as Vinz, in *La Haine*. Cassel first appears textually in his own character's dream sequence, dancing dementedly back and forth, leaping his acrobat body, bouncing with backflips to blaring Jewish trumpet music beneath a blazing underground spotlight. Next, a cut takes us, by contrast, to a medium close-up of Cassel's drooling face, passed out on his bed, asleep in his clothes, awakening grudgingly from uneasy dreams of a mystical cow; a sped-up track then finally ricochets into a close-up

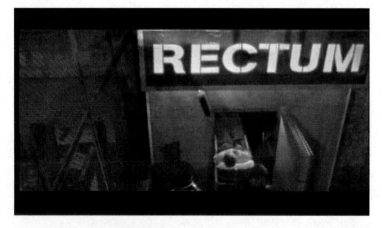

Figure 10: A crane shot introduces Marcus, his body leaving The Rectum, during Cassel's star entrance in segment 1

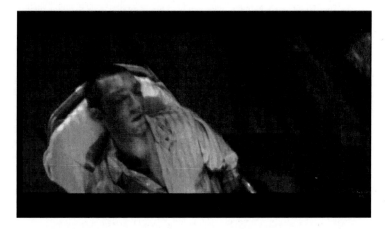

Figure 11: In closer shot, a catatonic Marcus conveyed into an ambulance in segment 1

of 'Vinz' in the form of a garish bling ring perched below the knuckles of
Cassel's clenched left hand. Vinz may be a petty *banlieue* thug here, just a
small-time loser (with distant echoes of Michel [Jean-Paul Belmondo] in
Breathless [1960]), but Cassel turns him into the ticking time bomb at *La
Haine*'s centre: a human powder keg waiting to go off, the embodiment of
the irrepressible violent energy festering within these bleak projects. Here
and elsewhere in his career, when offered such a *monstre sacré* gold mine as
Cassel, the temptation for film-makers seems to be to introduce him – quite
literally in *La Haine* – with as ludicrously blaring a fanfare as possible.

But not in *Irreversible*, whose pervasive vicious ironies emanate
from its central star triumvirate, whose charismatic bodies are at first
shown perversely muted, eerily becalmed. In *Irreversible* none of Noé's
main troupe enjoys star entrances – following the film's endless conceptual
reversals; instead, up front they get star exits: their bodies are unveiled
before the audience in physical disarray, as silenced spent forces, brutalized
remainders battered into submission. All three of these burnt-out wrecks
are, moreover, depicted initially being escorted summarily off-screen,

ushered, and institutionalized, into waiting ambulances. In segment 1 we
meet Marcus for the first time in high angle long shot from above and
behind, turning Cassel upside down. Cassel's catatonic body is shown tied
down under a blanket into a wheeled stretcher; his clothes are soiled and
ragged; his visible flesh glows an angry red, lit from above by the neon
scarlet Rectum sign as Marcus is pushed out through the swing doors of
the club's entrance; the spiteful joke here is that Cassel joins the film by
being egested on-screen. Arcing over Cassel's inert body, Noé's camera
next hustles into medium close-up, positioning us as viewers as one of the
leering rubbernecking onlookers whose taunts we now start to hear; we're
cheering Marcus's demise. As we stay with Cassel's body, moreover, hovering
awkwardly above as the police move it along, the stretcher bounces over
cracks in the asphalt, which, in another deft touch, makes Cassel's face
judder left and right, as if an unconscious force is making his head shake *no*
in vestigial defiance at the grim indignity of it all. Before the camera then
cranes back up and away, colour details in Noé's mise-en-scène amplify
Cassel's humbled circumstances: the flashing blue ambulance lights bring
out the livid purple bruise inflaming his upper right cheek; we see bands of
green and red (*Irreversible*'s defining primary colours) masking tape used
to graft a makeshift tire iron splint onto his broken right arm – Marcus's
improvised weapon in segments 2 and 3 turns into an invalid's crutch. A
bizarrely kinetic performer initially in *La Haine*, Cassel's manic energy is
in *Irreversible* utterly quelled – he dances for Kassovitz; he's deadened by
Noé. More broadly, while most viewers of *Irreversible*'s opening segment
might single out its visual design as the focal point of the film's barrage,
Noé is just as controlling, equally keen to assert his dominion, at the level of
performance, lingering over the details of exactly what he is prepared to do
to his stars.

Pierre–Dupontel and Alex–Bellucci, afterwards and echoing the fallen
Cassel, are similarly laid low at the start of their *Irreversible* tours of duty. An
incisive parallel to how much this duo remains in thrall to Marcus–Cassel,
ancillaries to this unpredictable screen sociopath, both figures are helpless

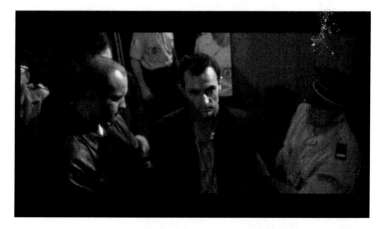

Figure 12: Pierre introduced, arrested and led out of The Rectum,
for Dupontel's star entrance in segment 1

subordinate foils to his selfish antics. Once Marcus has been deposited in
his ambulance, Noé's camera spins overhead in an apparent triumphant
flourish, looking down figuratively and literally as if, like the angry passers-
by, it gloats over Cassel's condition. (*Irreversible* keeps taking pains to
anthropomorphize its cinematography, another red rag to the film's more
bullish critics.) Thirty seconds later, the camera inverts a full 360-degree
sweep, craning backwards to return us to The Rectum doorway, hinting that
what follows is an impromptu afterthought or visual sidenote. On these
terms – and with an unidentified police officer yelling, 'Take this piece of
shit away!' in secondary rhyme to Cassel's entrance – Dupontel emerges,
blinking in confusion. Pierre's arrival prompts another round of off-screen
taunts; Dupontel the famous insult comic is at last being outdone by his
hecklers. And even in terms of this actor's customary pretextual shabbiness,
his usual weather-beaten form, Dupontel is rendered textually abysmal
here, much older than his actual 37 years at time of shooting. His mess of
hair is awry, squinting eyes rimmed with dank black lines, dirty forehead
riven by deep creased furrows, shirt caked in viscera and filth, rough-hewn

face sagging forwards in defeat. Emphatically, as well, this is no grandiose criminal being taken down: Dupontel's posture and gait exude shamed acquiescence, a guilty schoolboy caught *in flagrante delicto*. One skilful performance trick is the way Dupontel, as Pierre capitulates pathetically to the handcuffing police, lengthens his miserable strides, making each footfall an unbalanced lurch, like a somnambulist shambling unbidden through a nightmare, a compromised vessel with no one at the helm. Noé's mise-en-scène again compounds the sense of disgraced failure: as Pierre leaves The Rectum, the club's scarlet rear lighting spills out in a long rectangle before him, like an illuminated mock-red carpet that jeers his every step. Led away, Dupontel's introduction comes with Pierre clearly, appallingly, no longer the master of his own fate – if indeed, as *Irreversible* will claim about almost everything and everyone, he ever truly was. The final touch for a star prized for, and defined by, his incessant insouciant voice, is that Dupontel has here finally been shut up, switched off, put in his lowly place.

Bellucci gets special, albeit postponed, treatment. In the history of star entrances, from film actors on-screen to political candidates on-stage, an abidingly useful preparatory tactic has always been to delay their

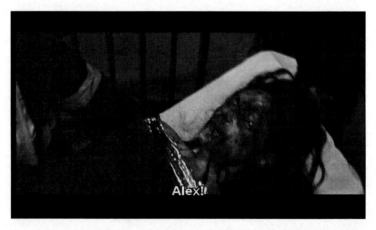

Figure 13: Alex introduced, for Bellucci's highly atypical star entrance, in segment 7

actual arrival, forcing the audience to wait, to become eager or frantic with frustrated desire to witness the desired star presence. Ever the keen manipulator, Noé thus defers Bellucci's first appearance in *Irreversible* for 41 excruciating minutes; the film is virtually half-over before Alex is glimpsed at all. And while Cassel and Dupontel are humbled when we first observe them, capitulating shells of former glories, Noé makes Bellucci's introduction radical to the point of outright vandalism; her first sequence plays like *Gilda*'s antithesis, referred to earlier via Hayworth's textual resplendence. Again, in spiteful echo of Cassel on his blanketed stretcher, Bellucci in segment 7 also shows up comatose, her once-coveted body hidden by and shrouded in medical wrappings; Alex is the passive recipient of horrible disabling violence. The famous Italian model has been turned grotesque: for nearly a minute of stuttering tracking shot alongside Alex's stretcher, we are forced to study what's left of her, her face, which has been beaten to a pulp, caked in congealing drying blood, a revolting mask of muddy reds and ruddy crimsons, like a smeared painter's palette. To pursue the artistic analogy: in treating Bellucci this way Noé is an agitprop insurgent daubing graffiti on the *Mona Lisa*, cynically destroying the sacred beautiful. Our reaction to this defiled Bellucci, Noé's amplification of her appalling state, is modified further by two textual factors here. The first is the complete turnaround in Cassel's performance during segment 7: Marcus starts out a strutting alpha male, promenading arrogantly down the street, cigarette in hand, swigging gulps from a phallic water bottle, sneering at Pierre for ruining the party; then he dissolves into a sobbing, shrieking wreck, clinging to Alex's passing body like a child as medical professionals prise him loose. The second intrusion comes from visual and aural style: sudden pounding heartbeats emitted by the soundtrack while the imagetrack concomitantly judders; Noé's entire mise-en-scène reverberates with aghast consciousness of such an ineradicable crime. (Once again, *Irreversible*'s rendering of the on-screen world feels mysteriously alive, aware of the degradations it perceives.) Bellucci's extraordinary star entrance, moreover, distils the entire *cinéma du corps* template. Built around a beautiful

body's startling desecration, *Irreversible*'s stylistic irruption creates a diegetic cacophony, the once-alluring Parisian cityscape conveyed to us in dangerous disarray; *cinéma du corps* nightlife contains the spectre of night death.

Irreversible's trio of star entrances, these clever deflations, are clearly designed to be momentous, structuring points of entry into Noé's whole diegetic equation, but this lead performance triptych sustains much of the film's powers of expression elsewhere too, in very different registers, moving from the abysmal to the euphoric. Especially in *Irreversible*'s latter half, as Noé's non-diegetic sound patterns and assaultive cinematography subside, the film comes to rely heavily on performance, and, more specifically, reflections on the pretextual-textual-extratextual composite of its stars. Consider segment 9, the party scene, a long take which runs for nearly 13 minutes, or 14% of the whole film. Built into this segment – once again *Irreversible*'s design runs the gamut from the hot-wired overblown to the deceptively organic – is another treatise about the film's star dynamic, and how intimately the film scrutinizes Cassel, alone, then Cassel matched with Bellucci, together. Segment 9 climactically shows Marcus and Pierre going downstairs, as Noé's camera, ahead of them, shifts its attentions to Alex. It circles around her deferentially, placing Alex central to, and focal point of, the dance floor. Two women, one either side of Alex, become enraptured supplicants, trying to solicit her gaze and match her movements. Bellucci, as is her stardom's textual norm, is made into a graphic linchpin, reliably supplied with adoring diegetic audiences; as Noé frames her dancing body in medium shot, Alex appears entranced by the music, immersed in its rhythms, at one with her body, aware of, but not hostage to, its physical charms. (Leaving aside segment 7's images of Alex's devastated body, the rapturous set-up here feels like Bellucci's secondary star entrance, a do-over that reinforces her customary on-screen glamour and agency.) Pierre stands to watch her display dolefully, but when Marcus arrives – bouncing on his heels as if warming up for the fray, wiping sweat off his face, flexing and scratching his underarm like the primate Pierre accuses him of resembling – his appreciation of Alex is far more active, delighted and participatory. After

a trademark pretextual Cassel tic – he bends forward to rub both hands over the top of his head, a forehead to nape-of-neck rasp, then juts his face forwards, revving himself up to hasty action – the first line Marcus directs at his lover sums up the situation. 'Look how gorgeous she is!' he crows.

Cassel's overexcited posturing is loosely justified by Marcus at this point having taken doses of at least two types of recreational drugs. But the real key is that here Cassel and Bellucci are for the first time in *Irreversible* united textually on-screen, a couple at last, and the final 30 minutes of Noé's film are, essentially, about exploring the terms of that romantic-sexual partnership, trading off its extratextual aura, identifying its capacity for regret and sorrow but also utopian mutual satisfaction, perfect love. Almost entirely missed by critics, unable to move past the opening assaults, *Irreversible* truly becomes for its final third an unorthodox classical-contemporary romance, alternately vulgar and sincere. In spite of, or perhaps because of, its entropic reversed narration *Irreversible*'s climactic love affair even in certain ways returns us to, and reinvents, the terms of studio-era Hollywood remarriage comedies. These idyllic unions, both literal and figurative, are established by Stanley Cavell from films like *His Girl Friday* (1940) and *The Philadelphia Story* (1940) as a feisty conversation forever in progress, a contingent fractious union of two active minds and bodies, a male–female double act with all the performative and sexual connotations that term supplies. Following the adventures of Cassel–Marcus and Bellucci–Alex, with Dupontel–Pierre alongside them their occasional court jester or fool, *Irreversible* morphs into an absorbing study of romantic poise and possibility, inviting us as onlookers to appreciate the nature of this star couple's coupledom. Echoing Cavell's conception of a cinematic romantic lexicon, a grammar of mutual desire and compatibility, *Irreversible* studies this couple's 'familiar gestures of propriety and intimacy...not only by way of feet and hand signals but in a lingo and tempo, and about events present and past.... They simply *appreciate* one another more than either of them appreciates anyone else, and they would rather be appreciated by one another more than by anyone else' (Cavell, 1981, p. 167).

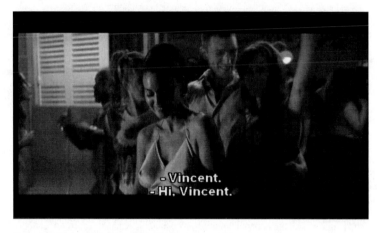

Figure 14: Marcus/Vincent reunited with Alex in segment 9

The romantic partnership of Cassel with Bellucci is further
configured by another exchange that comes seconds after the stars are
reunited. Marcus bounds forward, joining Alex's two admirers, while
Bellucci smiles indulgently in the shot's foreground. He then introduces
himself, with a deliberate comic Freudian slip, as *Vincent* – that is, not
as a fictional construct but as himself out of character – before quickly
recovering to correct the slip, smirking wolfishly, that his name is 'really
Marcus, and you?' (Marcus's line here was one of the very small list
of dialogues in Noé's original short treatment for *Irreversible*, a vital
structuring crosspiece.) Overcompensating in response, Marcus and Alex
now kiss before he demands, abruptly switching to English (the Cassel–
Bellucci marriage being extratextually renowned for being polylingual) that
she must repeat, and chant, his name: 'Marcus, Marcus!' The point is, in a
distant and uneven echo of Cary Grant, the architect of many of Cavell's
remarriage comedies, that, like Grant's (who famously jokes about his
unfortunate birth name, Archie Leach, in *His Girl Friday*, and is personally
addressed by Howard Hawks – 'Not yet, Cary!' – in *Monkey Business*

[1952]), Cassel's stardom also often hinges on such self-reflexive asides, and such arch, self-conscious formulation. The mise-en-abyme of 'Cassel' originates with his seminal formation in *La Haine*, recurrently an intertext to *Irreversible*, in which Cassel played 'Vinz', effectively himself again; at another point on-screen, moreover, Kassovitz highlights a close-up of a door buzzer clearly labelled as 'Cassel'. Far removed from Grant's classically handsome face, his urbane wit and introspective thoughtfulness, Cassel nonetheless shares his self-referential status as a mischievous trickster, charming but aggravating, an unravelling agent of chaos, forever a source of perplexing magnetic frustration. Cassel also follows Grant, moreover, through what Naremore describes as a propensity to enjoy 'peeking through the role...displayed not simply as a famous personality who is performing a role, but as the very essence of stardom – that is, as a remote, glamorous object who emits a glorious light simply by being "himself"' (1988, pp. 220–221).

The oscillations of this 'Cassel' essentially structure *Irreversible*'s culminating segments, as the film ponders, and invites us to ponder, which textual side of its schizophrenic leading man will prevail in this complicated unfolding romance with Alex – Marcus the loving caring boyfriend, or Marcus the demented oblivious savage. Noé's beautifully intricate design, part of *Irreversible*'s overarching trajectory, is predicated entirely upon his lead male star: a Cassel who begins as a depraved maniac (who fails in his homicidal revenge), then gradually becomes, inch by grudging inch, Alex's kind and compassionate partner. Embodied by Cassel, this is one of the main backwards conveyor belts of *Irreversible*'s narrative: initially the film portrays arbitrary destructive violence; then it turns climactically into a study of whether committed emotions, higher brain functions, might eventually triumph (ironically when hope for Marcus, Alex and Pierre has already been lost). So during and after the party scene of segment 9, *Irreversible* begins to debate 'Cassel' himself – Noé surrounds Marcus with constant commentary, chatter and barbs about his being less than the sum of his parts, a man endlessly not living up to his potential. Cassel the contemporary *monstre*

sacré, confirming his billing again, is categorically divided in half: part reasoning and emotive human being, part wild beast.

To Alex, in one micro-scene staged above segment 9's party on a balcony (a mise-en-scène of inflected romance par excellence), Marcus represents what drives her to angry distraction. We know by now, in addition, that the rupture of this argument will be the cause of her undoing and ruin. 'You know you're not fifteen anymore', Alex berates him in medium shot; Marcus continues to dance, simper and caper, immune to her anxiety. 'You can be so nice, so gentle', she continues, before dismissing him as a self-absorbed drugged-up fool. ('I'm clean as spring water', he protests in a complacent lie, before reintroducing himself in a new personality, another altered guise, with mock suave tones, as 'Jean-François'.) The last thing, perhaps the terminally last thing Alex says to her lover, in yet another pitiless *Irreversible* jab, is the line 'Don't touch me!' as she shoves Marcus away and strides off down the stairs. It is precisely Marcus's careless behaviour, Noé concludes, which drives Alex out of the party and into the clutches of a really dangerous male animal, one without any saving graces

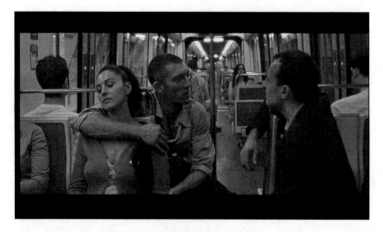

Figure 15: Pierre dissects the relationship between Alex and Marcus in segment 10

at all: Le Tenia, whose name means tapeworm, a destructive parasite who is waiting for her underground, outside.

Alongside Alex, reiterating and broadening her critique of Marcus, is Pierre. His attacks, all verbal, mainly come during segment 10, as the trio approaches the party by riding the Metro 7-bis line east from the Buttes Chaumont, eventually getting off at Pré-Saint-Gervais. Here, Dupontel (whose performance is just as mercurial as Cassel's; Bellucci is really the only consistent textual presence among *Irreversible*'s lead characters) plays Pierre by now assuming his familiar extratextual persona as a wheedling improvising offensive comedian, self-deprecating but snide, insatiably dissecting Cassel–Marcus and Bellucci–Alex's relationship. Cassel gamely tries to keep up with Dupontel, while Bellucci does her best to ignore him, periodically made uncomfortable (as a character and arguably, it appears, as a real person) by his close-to-the-bone jibes. Boarding the departing Metro train, Pierre convenes proceedings by announcing, 'Ladies and gentlemen, a couple that orgasms!' like a carnival barker hawking the wares of France's leading star couple, or a subway busker seeking public approval for his act. Inside the train cabin, however, no one pays any attention to Pierre at all, in one of Noé's rare nods to naturalism and diegetic plausibility. But Pierre keeps going: articulating himself as Marcus's intellectual counterpart, a philosopher whose only failing was his lack of physical finesse, personality traits gauged, in *Irreversible*'s typical rationale, by the levels of sexual gratification produced. The closest he ever managed to get Alex to climaxing, Pierre recounts in one representative anecdote, was when she wound up falling out of bed, smashing her head on their nightstand and screaming in pain and horror at the gushing blood, rather than from sexual satisfaction. 'Whereas he', Pierre reflects, bitterly but also smugly, inclining his head at Marcus, 'with his banana diet and testosterone – instant ecstasy!' Another culminating moment, when Pierre produces a pill, which Marcus gladly gulps down – less a pusher dispensing drugs than an adult providing medicine – further sets the terms of the triumvirate. Dupontel ends up bizarrely as a quasi-paternal figure, constantly entreating Cassel to tone

things down, pleading with him to make better choices, to attend more consistently to Bellucci, whom he endlessly, perhaps fatally, neglects.

An important finale to this arc of star-derived representations, though, is that to build momentum for *Irreversible*'s conclusion, in segment 11 Noé stages Cassel and Bellucci in a beatific state of bliss, corporeal nirvana. A *cinéma du corps* film to the last, *Irreversible* explicitly has its greatest point of confluence, the quintessence of human communion, in terms of these two stars' bodies blissfully entwined, in post-coital stasis. For the first three minutes of the 13-minute segment, indeed, Bellucci lies unmoving on top of her lover, Cassel, a pose which by consequence allows, and encourages, the viewer's eye to traverse this tableau of beautiful naked flesh; Cassel and Bellucci remain touching, or kissing, or embracing, or dancing, or sharing a cigarette, but maintaining physical contact for almost all of this ravishing long take. Casting dictates much of *Irreversible*'s design, as we have seen already, but here the Cassel–Bellucci star equation in part boils down simply to the yin-and-yang of their actual bodies, these entangled physical vessels. Hence Cassel's lithe muscular frame, with shaved head, angular facial features and bony ribbed midriff complementing visually – and thematically – Bellucci's more voluptuous lines, curved and rounded through her hips and chest, the spray of her long damp hair over the mattress. Although Cassel is six inches taller than Bellucci (she is 5′7″), he curves his attitude slightly throughout, craning over her so that here they look somehow almost the same length and mass, similarly harmonious in their autumnal skin tones and hue.

Irreversible's long take sequence shots take on multiple perspectival guises, from sustained cold scrutiny to leering kinetic amplification, but here Noé's cinematography, and above all Debie's lush penetrating orange lighting set-ups, confer a radiant home-movie aesthetic, tender and poignant. These moments play like genuine intimate happenstance, overtly flagged to us as improvisations: with dangling phrases or cut-off words, imprecise diction and occasionally erratic blocking, but constant fond emotional verisimilitude. These are physical ricochets between lovers

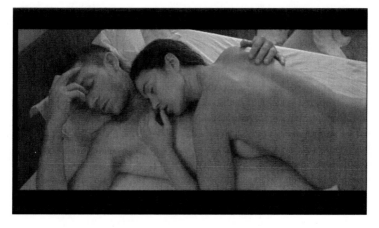

Figure 16: Corporeal splendour: Alex and Marcus sleep together at the opening of segment 11

that occasionally verge on erotic (several times they seem poised to make love; their genitals brush together; before he leaves, Cassel offers Bellucci his infamous kiss through and around her shower curtain), sometimes more coarse or raucous (both of them threaten each other with lovers' mock violence, they bite and mouth each other like rambunctious pack mates), but always infused by mutual comfort, warmth and humour, instinctual unforced rapport, a consummation of all the romantic energies inherent to the Cassel–Bellucci star couple, as we are given access to this, their innermost sanctum. Of all of the films Cassel and Bellucci have made together, few even try to approach the level of profound romantic coalition on offer, ultimately, in *Irreversible*; this scene may, in fact, be one of the most elating, genuinely revelatory of the sensory fulfilment of two people's cohabitation, in the history of cinema. Among all of *Irreversible*'s achievements – technical, conceptual and otherwise – it is most surprisingly this extraordinary climactic act of romantic fusion, a pair of bodies lyrically arrayed as one, that may be Noé's most overlooked, yet most provocative cinematic set piece of all.

✕ PART **6**

ALL OF THE EVIL OF THIS WORLD: *IRREVERSIBLE*'S CRITICAL RECEPTION IN FRANCE, THE UK AND NORTH AMERICA

For a film constitutionally inclined to split audiences, *Irreversible*'s divisive reception began from its first point of entry into the world, at the Cannes Film Festival. On 24 May 2002, midway through proceedings and shortly after *Irreversible*'s premiere, *Le Film français* commissioned via Médiamétrie a face-to-face survey of 418 festival attendees, asking them to estimate which film would win the coveted Palme d'Or. Half declared that they had no clear opinion, but among the rest *Irreversible* was listed as the outright front runner, main contender for the top prize, more than 2.5% ahead of its closest rival, David Cronenberg's *Spider* (2002). Palpably gleeful at these findings, *Le Film français* concluded with an energetic appraisal of *Irreversible*'s rising status: 'Tension builds around the film whose ink has barely finished drying: *Irreversible*... taking its place as lead favourite... there's a growing risk of yet more heat building up around the Bellucci–Cassel couple' (Anon., *Le Film français*, 2002). The same issue of *Le Film français* also disclosed that the festival jury (David Lynch [president], Sharon Stone, Michelle Yeoh, Christine Hakim, Régis Wargnier, Bille August, Raúl Ruiz, Claude Miller and Walter Salles) had requested to see Gaspar Noé's film in seclusion, at a special venue away from the ongoing crossfire of the public screenings. But in a decision widely reported as a contentious compromise, the jury ended up awarding the Palme d'Or to Roman Polanski's *The Pianist* (2002), a film whose reputation has not endured, which actually placed just third in *Le Film français*'s survey. Completely shut out of the Cannes prizes, third time unlucky for Noé, in what was taken as an outright snub after his early triumphs there, *Irreversible* ended up receiving smaller-scale vindication at the Stockholm Film Festival, where it won the first prize, the Bronze Horse.

Turning now to the issues involved in *Irreversible*'s reception, I will prioritize its initial release in France then assess its spread to the ancillary territories of the UK and North America. In broad terms, among French respondents, *Irreversible*'s arrival demonstrated the stern rigours enforced by such a film-literate and cinephilic nation; even such a polarizing limit

case showed how the French film ecosystem makes film-makers invited participants in the configuring currents of reception. Correspondingly, post-production in contemporary France does not simply end with a film-maker signing off on a final cut; he or she must sustain their contributions through self-presentations on the demanding French interview circuit, at festivals, conferences, in journalistic circles, schools and so forth. In the French press, therefore, while tempers might fray, a combative film-maker like Noé must still be reliably given a fair trial, held accountable for his actions but granted the opportunity of justifying his approach on artistic and applied cinephile terms. More generally, *Irreversible* also underlines how the French film press (as in the retroactive complexity of *Amelie*'s reception, noted earlier) prides itself on offering nuanced, multifaceted appraisals of higher-profile films, preferring multiple points of view to shrill or one-note dismissals.

The case of *Télérama* is instructive here. At first glance its account of *Irreversible* distils the negative press Noé's film initially received. *Télérama*'s lead reviewer, François Gorin, reported directly from the first screening at Cannes to denigrate *Irreversible*'s ambitions as 'a nauseating and facetious nightmare signed Gaspar Noé' (2002). Gorin echoes Jean-Marc Lalanne's first Cannes dispatch for *Cahiers du cinéma*, which called *Irreversible* 'ridiculous…a vendors gallery of cheap fantasies' (2002, p. 51). Confounded by its hybrid palette ('human misery at once naturalistic and stylized'), Gorin went on to vilify *Irreversible* as homophobic, a deliberate provocation aimed at David Lynch, Cannes jury president; but even worse in Gorin's eyes was Noé's film as a putative paradoxical text, its preordained nihilism derived from 'audacious formal instincts' that merely puff up the film's generic materials (of an unspecified type) worn on-screen 'like an old vest' (2002). Damned with faint praise (on formalist grounds), then damned with vitriol (primarily trained on The Rectum and segment 8's underpass; never has a 95-minute film been so widely appraised on evidence drawn from less than a third of its contents), an influential reception model for *Irreversible* had been set. Noé's aesthetic contortions, the argument ran, were mere

window dressing, a distraction from his cynical pessimism about human depravities.

But setting a critical stall against *Irreversible* was only rarely the last word among its French (and occasionally also international) respondents. The French critical template often safeguards a back-and-forth process of conversation, rather than outright demagoguery. Confronted by Noé and his film, by consequence, when supervising French editors considered their critics to be excessively negative, they often counter-commissioned accompanying, mitigating essays. (This offsetting editorial process takes us all the way back to André Bazin prefacing with deflating remarks, as well as encouraging rewrites of, Truffaut's notorious glib polemic, 'A Certain Tendency of the French Cinema', in the January 1954 issue of *Cahiers du cinéma*.) Hence a recurrent motif in *Irreversible*'s reception, in France and beyond, was a point-counterpoint model, critical controversy implemented at a structural level. At *Positif*, for instance, Grégory Valens adopted a familiar position of confrontation – that *Irreversible* was 'irresponsible', stirring up trouble for superficial kicks; a quasi-paternalist viewpoint that such a film's 'extremist discourses' would oppress spectators 'not always having sufficient maturity' to process their expressive weight (2002, p. 111). Underneath Valens's attack, though, came an extraordinary three-line editorial disclaimer, in which *Positif* adjudged that a minority of its governing committee was so unconvinced by Valens's account to have '*donné la parole*' (literally 'given the right of words') to Philippe Rouyer, for a radically different view. On the next double-page spread then came Rouyer's oppositional interpretation, arguably the most sympathetic piece of *Irreversible*'s first-wave criticism, one of the very few write-ups to assess the significance of the film's neglected later segments. Rouyer argued, in fact, for the profound implications of Noé's design, instantiating on-screen a contemporary paradise lost, a domestic unit and diegetic world whose balance is inverted, then decimated, in a 'brilliant and unclassifiable [film] at the crossroads between horror film and auteur cinema' (2002, p. 114). This fascinating process of doubled reviewing, with newspapers and magazines

divided among their own critical staff, thereafter sometimes continued outside France, in the UK (at *Sight and Sound*) and the US (at *The Boston Globe*).

Part of the back-and-forth inspired by *Irreversible*, equally, came from the fact that in contemporary France, film criticism intersects with film practice; film-makers and film writers must speak each other's language. So alongside its negative write-up, *Télérama* also published an interview, with the scathing Gorin joined by the more neutral Laurent Rigoulet, offering Noé an opportunity to rebut the review's lines of attack, which he did, in another long-term strategy, by outlining *Irreversible*'s ancestry within world cinema. To the most challenging dismissals (such as one line, a statement not a question: 'Your vision of the gay nightclub, where the murder happens, is a frankly retrograde vision of hell'), Noé correspondingly cited the example of Pier Paolo Pasolini's *Salò* (1975), and Rainer Werner Fassbinder's *Fox and His Friends* (1975). Do their scenes 'of men, gay or not, charged up with electricity', Noé replied, bespeak homophobia, in films made either by an openly gay film-maker or one avowedly gay-friendly? (Gorin and Rigoulet, 2002). In similar fashion, versus Gorin's allegations of facile furor-mongering (putatively a 'desire to make people leave, of shocking and scandalizing'), specifically in the scenes of Marcus's physical and verbal assaults on a Chinese taxi driver and gay patrons of The Rectum, Noé was calm, philosophical. 'There's so much fear today', Noé responded, 'about making films that offend communities, but, to me, man is fundamentally barbaric, and that can't be represented authentically without showing him when he loses control of his actions' (Gorin and Rigoulet, 2002). Clearly the winner of the bout, Noé concluded with his guiding rationale, a policy for progressive cinema. Neither a slave to political correctness nor a drone perpetuating predictable didactic realism, Noé argued that a film-maker's true calling was to instantiate through uncompromised style their diegetic vision of the world, a reconstituting and fundamentally *ambivalent* artistic treatment. From such an approach, Noé argued, came the enduring legacy of divisive complex

works from Luis Buñuel's *L'Age d'or* (1930) to Kenneth Anger's entire oeuvre, to Lynch's *Eraserhead* (1977).

Amplifying this testimonial aspect of *Irreversible*'s French reception, sometimes Noé's manifestoes were joined by those of his stars (crucial to the film again, off- as well as on-screen), who rallied around their embattled director. At *Les Inrockuptibles*, often called France's most influential pop-culture magazine, *Irreversible* at first received the typical dichotomy of critical responses, its customary *pour et contre*. In the former category wrote an impassioned Olivier Père (a noted sympathizer of the *cinéma du corps*, it must be said), hailing *Irreversible* as being 'no contest, in its form and its mise-en-scène, one of the most singular propositions in cinema in recent years, a sensorial and emotional shock that is difficult to forget...it would be unjust to circumscribe it as merely an immature provocation' (2002). Next, in contrast, came Frédéric Bonnaud, far more grudging, sneering at Noé's 'film-gadget', a project graced by the 'effects of intimacy from the Bellucci–Cassel couple' that amounted just to a 'meticulous spectacle of misery moulded by a contented pout' (2002). Dominant over both reviewers, however, was *Les Inrockuptibles*'s senior writer, Serge Kaganski, whose three-way interview with Noé, Bellucci and Cassel articulated concerted rationales for *Irreversible*'s design. Cassel described *Irreversible*'s 'adventure' (for both its participants and its viewers) as stemming from its authenticity, acknowledging especially its citations of his real-life relationship with Bellucci, a factor he felt was already being missed by the film's opponents. Bellucci confirmed the sense of 'complicity' she volunteered, on- and off-screen, that took her and the watching audience to its limits; both actors underlined the logistically and artistically multilayered *Irreversible* narrative, notably in its 'first and primary subject', its overlooked 'romance, love, and sex scenes' (Kaganski, 2002). Noé, alongside them, confirmed his stars' shaping role on *Irreversible* during both conception and execution (and also presumably by extension its reception). Principal evidence here was Noé's affirmation, again, that it was Bellucci who had designed the direction and staging of *Irreversible*'s underpass scene, which became more protracted from

her input, whose representational impact, he felt, came from her repertoire of anguished hand gestures and appeals to the camera, one of the subtleties of *Irreversible* that, again, was being ignored (Kaganski, 2002). Similar group defences were made by this trio at *Le Nouvel observateur*, *Le Journal du Dimanche* and *France-soir* – that *Irreversible*'s so-called stylistic shock tactics were actually close citations of avant-garde films like Tony Conrad's *The Flicker* (1965); that the film's sincere textual counterpoints to rape and sexual aggression (that is, its scenes of tender intimacy) had been skipped over by superficial detractors; and that, overall, they ironically actually felt happy to see their *Irreversible* booed, as it showed that cynical contemporary audiences were being dislodged from a false position of supremacy.

From the perspective of critical reception, another rationale for *Irreversible*'s value, its contributions to world film culture, is that its appearance prompted individuals and institutions alike to reconsider their fundamental conceptions of what cinema is, the limits of its acceptable remit. Whatever your stake in Noé's film, whether to repudiate or rationalize, the onus was on you to define your position, to ground your conclusions. In Britain, *Irreversible*'s appearance cued not just a series of critical discourses, in large part recasting the reactions from Noé's French respondents, but also wound up underlining important shifts in organizational policy within the British Board of Film Classification (BBFC). Tracking advance word from Cannes, the British press at first predictably echoed the now standard terms of controversy for the looming French export – Noé's was a shocking film, explicit in its violence and sex, stylistically abrasive, defined almost exclusively in critical terms by its two-scene (The Rectum; the underpass) headlining diptych. In *Sight and Sound*, for example, Nick James foretold that *Irreversible*'s looming arrival was going 'to provoke this year's moral panic' (2002, p. 16). Premiering in Britain at the Edinburgh Film Festival in August 2002, however, *Irreversible*'s entrance into the UK was actually comparatively subdued. S. F. Said representatively reported for *The Telegraph* the 'pleasant surprise' and 'lack of hysteria' of a festival screening at which merely a handful of attendees left, leading

to a subsequently collegial press conference at which 'Noé earned respect for the calmness and clarity with which he defended his work' (2002). On the basis of this comparative success, shortly thereafter Metro Tartan bought the distribution rights from Wild Bunch, Noé's French distributor, making the UK one of the first European markets to acquire *Irreversible* for international release.

More fundamental, however, to *Irreversible*'s import into Britain was the conversation it initiated as a lightning rod, a configuring pivot of evolving British rules about censorship. At that initial Edinburgh conference, as reported by Robert Mitchell of *Screen Daily*, Noé took the opportunity to argue for *Irreversible* to be passed uncut for its UK release, thereby avoiding the fate of fellow *cinéma du corps* arrivals *Baise-moi* and *The Pornographer*, both of which had had explicit sexual sequences cut (hard-core insert shots from a rape scene in the former; an ejaculation shot in the latter). As Noé pitched his project, censoring *Irreversible* would be incomprehensible when it had so recently been shown complete at Cannes: 'This is not a dangerous film', he opined: 'It is more likely to cool down the spirits of anyone into power-trips' (Mitchell, 2002). As discussed by Daniel Hickin, what then transpired was exactly what Noé wanted, which was *Irreversible*'s passage into uncensored UK distribution, the beneficiary of the increasingly liberalized BBFC's institutional course away from direct textual interventions: reasoned analysis instead of scissors and splices by default. Despite reactionary calls to censor Noé – Alexander Walker, a vocal ringleader, in the *Evening Standard* reduced *Irreversible* to, yet again, a 'nine-minute rape sequence in an underpass' (Hickin, 2011, p. 125) – the BBFC convened a hearing, then issued its press release on 21 October 2002, first rejecting the more strident press backlash, then emphasizing instead the 'serious intent' and 'artistic merit' of Noé's work, which was French (hence intellectually respectable) and, above all, 'not designed to titillate' (Hickin, 2011, pp. 125–126). Corresponding instead with *Irreversible*'s supporters (such as Peter Bradshaw at *The Guardian*), the BBFC's decision, in Hickin's account, 'heralded the emergence of a new form of provocative European cinema that coincided with the beginning of an

increasingly open, accountable and liberalized form of British film censorship'
(Hickin, 2011, p. 128).

In North America, too, *Irreversible*'s passage onto screens was
never smooth, but after an initial spate of superficial dismissals (in *The
Chicago Reader* Jonathan Rosenbaum oxymoronically called it 'stupid and
odious ... [yet] interesting for the way it plays with the viewer's nerves'
[2003]), Noé's film inspired some of its most fluent, committed responses
since its fractious Cannes debut. From the Toronto Film Festival in
September 2002, to Sundance four months later, forewarned critics
began to unite around the notion that dividing *Irreversible*'s style from its
content – the most common hostile template, stemming from the *Télérama*
and *Cahiers du cinéma* reactions – was invalid as a rationale for devaluing
Noé's project. One perceptive essay, succinctly titled, '*Irreversible*: Put in
Perspective', by Dominique Pellerin in the Montréal cinéclub journal
Séquences (that also featured an interview with Noé), offered the telling
observation that ultimately *Irreversible* hinged entirely upon spectator
response. What critics really found 'intolerable' in *Irreversible*, Pellerin
suggests, is its systematic disruption of habitual or blithe cinematic viewing
experiences, and, by extension, the prevailing smugness that informs most
accounts of more challenging film festival line-ups. In sharp contrast,
Pellerin concludes, if we are honest, *Irreversible* forces us to reflect on our
status 'as at once spectators and as human beings' (2002, p. 221).

By this stage Noé's film was gathering momentum as a worthwhile
film to defend, a text that rewarded closer attention, around which, more
importantly, a critical philosophy could be built. Matt Bailey, in an ingenious
2003 online account, positioned *Irreversible* as a contemporary descendent
of Tom Gunning's model of attractions, derived from early film, Sergei
Eisenstein and Grand Guignol theatre alike, in which counter-narrative
designs instantiate an array of shocks, stimuli both pleasurable and repulsive,
designed to render an audience off balance, unnerved but engaged, highly
susceptible to aesthetic suggestion (2003). More high profile, Roger Ebert,
perhaps unsurprisingly given his historical endorsement of American

avant-garde film-makers, also offered Noé support. Although not entirely favourable towards *Irreversible*, Ebert painstakingly offset charges that Noé condoned or sanctioned the sexual aggressions on-screen: 'The fact is, the reverse chronology makes *Irreversible* a film that structurally argues against rape and violence, while ordinary chronology would lead us down a seductive narrative path towards a shocking, exploitative payoff' (Ebert, 2003). Mikita Brottman and David Sterritt, equally, in *Film Quarterly* approached *Irreversible* on moral grounds, making the case that its confrontational materials, especially its narrative design, 'can be regarded as a synecdoche for twentieth-century thought, which has been characterized by the breakdown of previous meaning systems and subsequent feelings of disillusionment, apathy, and anxiety' (2004, p. 41).

The culmination of North America's critical response to *Irreversible*, in many ways, came from veteran film writer Robin Wood, whose 'Against and For *Irreversible*' not only encapsulated the majority of the critical discourse hitherto generated, but also offered a poignant humanist rejoinder to Noé's detractors. Typically wry, Wood observed first the predilection for hostile respondents to focus only on *Irreversible*'s two most off-putting scenes, in the nightclub and the underpass: 'One might reasonably have concluded that these were the only two scenes in the film, despite the fact that they occupy only about one-sixth of the screen time' (2003). Instead, Wood steered the conversation towards Noé's overt commitments: *Irreversible*'s fundamentally justified protracted representation of rape 'I would like to challenge the film's outraged attackers to tell us how…it could be presented with greater intelligence and integrity', and its climactic counterbalancing of the preceding horrors with an idyllic resolution 'a mystical image of rebirth, perhaps of human perfectibility, somehow miraculously freed from the constraints and impossible contradictions and struggles of human life' (2003). One of Wood's most beautifully nuanced late-career pieces of criticism, akin to his 1960s and 1970s appraisals of Yasujiro Ozu and Kenji Mizoguchi as worthy of canonical recognition, the *Irreversible* essay ends on terms of perhaps appropriately weighted sincere qualified respect: 'I hope I

have made it clear that, despite major reservations, I believe *Irreversible* to be great...an extremely important film' (2003). From denunciations at Cannes to unflinching statements of enthusiasm like this a year later, *Irreversible*, in other words, had itself ended up running a long-term critical gauntlet: beset on all sides by its opposition, conversely sustained by its diverse, growing, resolute body of admirers.

✖ Part 7

BELLUCCI'S BODY: FROM RAPE TO REVERENCE

Among its many dichotomies and disharmonies, some of which affected its initial critical respondents, one of *Irreversible*'s foremost diegetic strategies relates to the body of Monica Bellucci. At one pole, in segments 7 and 8, Alex is terribly physically violated: raped, beaten, brutalized to the brink of death. The only hint of her precarious survival, indeed, is that as Alex's body is removed from its crime scene, the ambulance workers have not (yet?) covered up her face; apparently she breathes still. At the opposite pole, however, in *Irreversible*'s final segments, 11, 12 and 13, Alex is corporeally venerated, a source of awe and epiphany. At this textual climax but temporal point of origin, Alex is represented two-fold: on inflated terms (her body is immaculately restored, as is her position as a cue for passionate *romantic* desire; she is revealed to be pregnant, situated by Gaspar Noé not just as an earth mother but a galactic one too); as well as through deflated banalities: the only character in *Irreversible* ever to be depicted alone, an individual apart, Alex is therein shown engaged by corporeal minutiae – showering, drying herself, inspecting her face for blemishes, grooming, urinating, laughing to herself, thinking, reading, sleeping, sitting in repose. *Irreversible*'s final conglomeration of Bellucci, its suite of physical states, essentially feels like Alex's recovery from the preceding/awaiting tribulations, as she surpasses them to become incandescent. Yet while Alex's status as a defiled object of rape has been widely studied, denounced and just as zealously justified, this latter position of her concomitant veneration has been ignored. This is a fundamental oversight, given Noé's obsessive focus throughout *Irreversible* upon pairings, departures and destinations, contrasted yet corresponding corporeal conditions and stylistic parameters. This section, then, will consider *Irreversible*'s instantiation of Bellucci's body, from rape to reverence, as one of Noé's primary discursive forms.

How is the rape established? There are three defining principles – stylistic, cultural and geographic – to this sequence shot, one of *Irreversible*'s most infamous. From a technical standpoint, segment 8 opens with one of Noé and Benoît Debie's trademark set-ups, even more prevalent and stylized in *Enter the Void*: a very long take tracking shot (here 12 minutes and 23

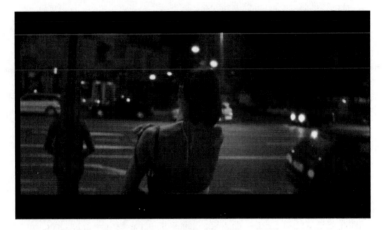

Figure 17: Alex enters the cityscape at the opening of segment 8

seconds in duration), handheld but calmly executed, with very shallow focus and narrow depth of field, occupying a vantage point behind and slightly adjacent to a figure whose movements are trailed, but whose face is at the outset almost always not shown, who thus becomes both focal point of, and displaced conduit to, the images of propulsion and activity that ensue. The shot attends Bellucci in mobile medium shot, as Alex exits an apartment building, purse on her shoulder, then walks perpendicularly to a street, well lit, which has four lanes of busy night traffic plus an unused bus lane. Alex advances, and we see a woman in long shot right approach and talk to a man through the window of his parked car, whose engine keeps running; this is clearly a road along which prostitutes are soliciting trade. Cars, vans and a coach go by; one passing vehicle sounds its horn (upon seeing the camera?). Alex tries – forever perplexingly, just once – and fails to hail a taxi; another young woman leaning on a lamppost to screen left, revealed as the camera pans over, suggests that Alex should take the underpass as this road isn't safe to cross. Alex thanks her for the advice, then without delay turns left and descends; the camera follows.

Already *Irreversible*'s stylistic logic is ordained. The camera will observe this person continuously, without deferring to cutaways, and concomitantly it won't offer stylistic amplifications or interventions. Unlike the brash competing stimuli of *Irreversible*'s opening segments, now Noé's cinematography is measured, deceptively unassuming, marking time, attuning us to watch regimented things like the passing of traffic, in the form of both vehicles and people. Staged (initially) from the rear, oriented to the undulations of Bellucci's body, this shot will also withhold explanatory close-ups and details of, and proximity to, faces, such as Alex's; a sly implication about an aesthetics of the meat market, perhaps. Overt shallow focus, moreover, restricts our plane of sight to the middleground in this deep staged diegetic space, abstracting Bellucci's movements slightly and underlining the visual delimitation in progress. To anthropomorphize this imagetrack, as Noé and Debie prompt us variously in *Irreversible*, we might reasonably consider ourselves to be positioned behind Alex like her trailing Sherpa or subordinate, but no binding contract has been signed, no promise of help or involvement exists. We are not optically a predator, but neither are we Alex's friend or accomplice. (This stylistic ambivalence interestingly undercuts Bellucci's self-definition of her screen stardom, analysed earlier, as needing the camera's complicity in what she does on-screen.) On these terms, as Alex heads to her fate, we are, in sum, placed concretely within events, but on the periphery of the diegetic arena of action. We are also offset and withdrawn from the frame's emotional centre, Alex's face, and denied access to the human and/or emotional ramifications of what is to happen. Prefacing the atrocities to come, *Irreversible*'s viewpoint here instils measured aesthetic dispassion; the progress of character and camera are as neutral as the turning of cogs in a machine.

Stylistically balanced like this, poised between indifference and danger, this segment also has a strong, even pungent cultural resonance. Noé and Debie's shot ends with rape and horror, but it begins declaratively, with Alex imbued with the agency of a *flâneuse*, that most enduring of Parisian archetypes. Stepping forth into a nightscape hers for the taking,

Alex is primed to partake of the city as she sees fit; the wide angle sweep
of *Irreversible*'s mise-en-scène accentuates the urban space opening up
before her as the apartment building's door swings ajar. Famously coined
by Charles Baudelaire, this strolling *flâneur*, a French cultural fixture since
the nineteenth century, is traditionally propelled by peripatetic excursions
into the busy urban experience, moving on foot, dressed to kill, behaving as
a dandy, readied for all the modern stimulations of haphazard scopophilia.
Translated in the twentieth century into photography and media, profoundly
feminized, the *flâneuse* has enjoyed an especially fluent rendition through
French cinema, most iconically informing Agnès Varda's *Cleo from 5 to
7* (1962). As defined by Mark Betz from its 1960s European art cinema
heyday, the *flâneuse*'s most positive associations represent nothing less
than 'poise and freedom of movement...exploring the public architectures
of the modern city and traversing its spaces with ease' (2009, p. 95). Via
Irreversible's Alex, however, through this one undeviating long take, the
cinéma du corps revisits one of its central cultural corruptions, again recasting
promise and potential as entropic threat. From strolling mobile participant
in a vibrant panoply of lived experience, Alex the *flâneuse* is thereby finally
incapacitated, robbed of agency, turned into an inert, subterranean victim,
subsiding into the ground below.

The final aspect to situate the underpass sequence is *where* it takes
place, *Irreversible*'s vision of Parisian topography and space. In reality the
scene was filmed at 118 boulevard Berthier, to the northwest of Paris's
seventeenth arrondissement, a third of a mile, just five minutes' walk,
from the Pereire-Levallois Réseau Express Régional (Regional Express
Network) station. Viewed today, the actual street and its surrounding
neighbourhood have since Noé's 2001 shoot gentrified: its tree-lined
sidewalks are nowadays a little more verdant, its ordered and mainly
residential buildings clean and well maintained. If you look right, rather
than to Alex's (and Noé's camera's) left, the skyline actually opens up:
in the real world this is a pleasantly expansive, not claustrophobic, vista.
Irreversible is rife with dark ironies, and yet another one comes here from

a civic planning decision. In 2007 the Berthier underpass was filled in and demolished, replaced permanently with an aboveground, brightly painted pedestrian crossing. No one need ever go down there, run that gauntlet, ever again. The rationale for the decision was not publicized (did locals complain? YouTube postings confirm that unwelcome ghouls did visit Noé's crime scene), but today this infamous stretch of Parisian passageway has been stricken from the record, an anti-landmark and grim pilgrimage now occluded.

Diegetically, however, within *Irreversible*'s unnatural version of Paris, Le Tenia's desolate underpass is situated for us somewhere to the far northeast of the city, further out than the Pré-Saint-Gervais Metro station at which we see Marcus, Pierre and Alex disembark in segment 10, heading for their party which is still a taxi ride away, somewhere beyond the reach of the subway. This comparatively distant area, spilling out beyond Paris's encircling *périphérique* bypass motorway, past the edge of the nineteenth arrondissement, extends *Irreversible*'s geography to a kind of symbolic spatial shorthand: crossing the threshold of no return, going off the grid, leaving the civilized confines of central Paris to venture into its urban hinterlands. (We have already seen this notion of the exponentially increasing dangers of leaving greater Paris unfold in *banlieue* films like *La Haine*; it also subtends many twenty-first-century French horror films, from *Sheitan* to *Frontière/s* [2007] [Palmer, 2011, pp. 132–134].) Le Pré-Saint-Gervais is actually one of the most densely populated municipalities in Europe, with over 24,000 citizens per square kilometre; it was belatedly, but only partially, incorporated into Paris in 1860, remaining thereafter partly inside, partly outside, the city limits. Yet Noé's connotations distil the aura of this area, reviving but superseding the zone immortalized by Dmitri Kirsanoff in *Ménilmontant* (1926), its once-outlying neighbour to the south, as an urban fringe, an inhospitable frontier prone to violence, unsafe for the unwary. These are outskirts distanced from civilization and law and order, inhabited by ne'er-do-wells, thugs and casual killers, denizens of the underworld. This is Le Tenia's stamping ground.

Aboveground, women on the boulevard are their own vendors, negotiating their terms of corporeal trade; belowground, they are chattel, Le Tenia's playthings. Alex nears the angry-red tunnel, its glowing scarlet walls and lights the product of one of Noé's caustic digital accents; the passage is turned into an abattoir, its walls stained with fresh blood: the colour also rhymes on-screen with the unfocused red circles of car brake lights, those recurrent pauses for sexual commerce we have already seen in progress at street level. (Douglas Keesey also links graphically this coloured patterning to the phallic red fire extinguisher with which Pierre carries out murder in The Rectum [Keesey, 2010, p. 99].) The final red expressive label – apart from Alex and Concha's own (fake) blood – comes with the only micro-deviation in Noé's otherwise unified cinematography system. With Alex just steps away from her third and last leftward turn, under the roadway, before she is robbed of her powers of locomotion, the camera tilts up, for the only time in this segment independent from Alex's movements. Glancing aloft, the camera briefly regards the scarlet neon PASSAGE sign hanging over Alex's head, two downward arrows and seven bright white letters, the final confirmation that Alex's trajectory underneath will take her into a netherworld, a secular hell, a gateway from one place, and state, into another; this is also another of the many signs throughout Irreversible, as Noé remarked in several interviews, that people stubbornly fail to heed (Sterritt, 2007, p. 308). As always within his long takes, Noé's choreography and blocking are devastatingly precise: Alex is just six steps (five wall panels) away from traversing the corridor, from reaching the other side, when Le Tenia and Concha enter, at loggerheads. Le Tenia instinctually attacks: first Concha, then Alex, and now Irreversible's die is cast. Notably Le Tenia's first accost of Alex is verbal – he yells at her, 'Wait a second!' – a line that becomes another of Noé's mordant temporal puns, about the ephemeral versus the enduring, his recognition of those flashpoint instants upon which lives fatally pivot.

The culmination of the segment is corporeal and aesthetic devastation. Le Tenia forces Alex to the ground at knifepoint – 'On your knees, lie

down!' – and Noé's camera also complies; these movements, of two bodies and one camera, are all measures of coercion. The imagetrack's previously gentle oscillations now freeze into stasis, and irrespective of the human violence unleashed, this stilling of the camera, visually turned from handheld to held down, is itself frighteningly oppressive, as if we too are being strong-armed, intimidated into obeisance. (In a masterclass given at the British Film Institute in October 2009, Noé disclosed that as a camera operator filming this moment, he felt literally unable to move, either himself or his camera, like he'd reached a complete technical and artistic breakdown; Noé also averred that Bellucci herself blocked and directed the scene, which had the shortest description of all the segments in the film's original treatment [Cox, 2009; Torreo, 2003].) In its sheer duration, the rape's real-time conflation of diegetic and extra-diegetic exposure – Alex and the viewer must suffer at length – has been described by Estelle Bayon (who calls Noé's a 'physiological cinema') as obligating our painful immersion and interaction: '[B]y implicating [the audience] physically rather than merely intellectually, verbally, cinema as a physical discourse makes one feel, really' (2007, p. 127). For just over six minutes the camera stays still; it only rallies, pathetically, after Le Tenia rolls off Alex, who then, still on the ground, tries to crawl away, inducing a series of tiny twitching pans, hideous reframes like someone trying and failing to muster strength. Then, finally, Bellucci's face is for the only time shown in closer view, while the camera inverts its axis, lurching closer, as Le Tenia ends his spree by smashing Alex's head against the ground.

Le Tenia rapes Alex, one body contaminating another, and so too are the matters of Noé's staging shot through with dualities, competing yet inescapably interrelated binary sources, textual oxymorons that grate. From the perspective of performance, there is the matter of voices; a limit case, surely, for the *cinéma du corps*' capacity to deconstruct and realign the human voice box as a source of visceral representations, uttered words dissolving into noise, orchestrations of pain, dominance and supplication. Thus Alex's rhythmic guttural shrieks as Le Tenia pulses on top of her; the

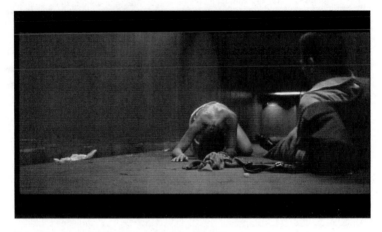

Figure 18: Alex in the blood-red underpass in segment 8

gagging treble of her cries, muffled by Le Tenia's restraining right hand,
hideously interact, syncopate, with his baritone murmurs of appreciation,
expressions offered like a gourmet appraising the wares of a classy restaurant,
his running vocalized commentaries extending the range of his depravities:
'I'm gonna destroy you'; 'Say "Daddy, it's good"'. Also related to acting is
a corollary split component of this scene – Jo Prestia himself, a typically
abrasive piece of Noé casting. As Le Tenia, Prestia projects simultaneously
his extratextual profile as a publically licensed disseminator of violence (an
ex-world champion Thai kick-boxer whose face and [many times broken]
nose are ravaged by scars); realigned textually, contingently, to the more
controlled skills of an actor (Prestia was first discovered as a film performer
by Erick Zonca, playing a bouncer with a repressed emotional life in another
crucial 1990s French film, *The Dreamlife of Angels* [1998].) Alex and Le
Tenia are two bodies, but there is also a third – the rape scene's pivotal
paradox, widely discussed, is that midway through proceedings a passer-by
enters the underpass, distantly visible in blurred extreme long shot, sees the
violence taking place, then retreats instead of interceding. But even here Noé

supplies more. Given the state to which Alex is reduced, her utter incapacity, someone else, not shown, *must* actually have intervened in belated rescue later, even if just to call the police and summon an ambulance. In *Irreversible*, Noé provides more than enough to digest in terms of what we actually see and hear, yet we do need to pause occasionally to think on what is merely implied. Somewhere out there, maybe, there is a Samaritan.

The upshot of *Irreversible*'s treatment of rape is that above all it is overt, protracted, deliberate and emphatic, stylized but in ways that do not obviate the viewer of its wrenching impact. Connected to this is a revisionist essay by Dominique Russell, in which she argues that rape is historically a configuring component not just of salaciously designed rape-revenge pulp narratives, but also, 'whether we like it or not', of international art cinema itself. In an ancestry stretching from *Broken Blossoms* (1919) to *Partie de campagne* (1936), from *Rocco and His Brothers* (1960) to *Mouchette* (1967), from *Last Tango in Paris* (1973) to *Kika* (1993) and beyond, Russell argues that rape anchors much art cinema: it 'serves as metaphor, symbol, plot device, for character transformation, catalyst or narrative resolution' (2010, p. 4). Noé here in *Irreversible* therefore inherits, as elsewhere, a continuum of materials, but his applied cinephilia explicitly opposes the use of cinematic rape either as a means for abstruse stylized abstraction, or else for didactic socio political critique, two of the most common approaches in Russell's illuminating quasi-canon. To cement this point, we can briefly contrast *Irreversible* with two of world cinema's most famous test cases, in this light, of films bent on murdering and/or raping their lead female characters, played by major stars: Janet Leigh in *Psycho* and Mitsuko Mito in *Ugetsu* (1953). The former desecration, by Alfred Hitchcock, treats Leigh's body as a compendium of body parts set to screeching score, a bravura formalist set piece; in one of its most famous analyses *Psycho*'s shower scene 'aestheticizes the horror…[such that] we receive the most powerful *impression* of violence, brutality and despair' (Perkins, 1972, p. 108). On the other hand is Mizoguchi's conception, in which Ohama's (Mito) off-screen, below-camera rape dissolves into a Buddhist statue, then a shot of retreating rapist soldiers

tossing coins onto her body, explicitly depicting a woman falling prey to the patriarchal mechanisms of (feudal) Japanese power: religion, the military and capitalism. But Noé embeds Alex's rape within the complexities of his shifting overarching textual design: to the intense frustration of most of *Irreversible*'s respondents, the crime Le Tenia commits is neither discreetly obscured (as in Mizoguchi) and conscripted into a polemical treatise, nor is it turned into a kaleidoscopic barrage of film style per se (as by Hitchcock). The rape act is one of absolute force disbursed, but our viewing position in relation to it in *Irreversible* is conditional, not absolute.

Further complexity, the film's own main textual counterpoint, is that subjugation to rape is most emphatically neither the only nor the central configuration of Bellucci's body, as Alex, in *Irreversible*. Hard to drag our focus away from that blood-red underpass – and few critics try to leave either it or The Rectum behind – but in any case, whichever way you gauge Bellucci/Alex's expressive input to Noé's film (structurally, in terms of screen duration, as a plot point, a star, an intertext, a series of representational image systems), the zenith of her role in *Irreversible* occurs in its final three sequence shots. The trio, of segments 11, 12 and 13, completely reorient our relationship to Alex, leaving her empowered and hallowed, in the throes of profound restitution. This climactic series of corporeal studies, of Alex inhabiting states of reflection and repose, leaves her tantamount to a source of feminine majesty, conferring an alternative course to Noé's citations of and around the female body. *Irreversible* takes us from rape to reverence, recalibrating its signifying repertoire as it goes.

Most vitally there is the notion of painterly beauty climactically expressed through Bellucci's body – her physical luminescence, an apex to corporeal empowerment within a redefined mise-en-scène, the prospect of Alex's liberation. Initially, as Alex awakens from delicious slumber in segment 11, we should recall Noé's own situation as the son of an important Argentinian artist, Luis Felipe Noé, whose materials, mentioned earlier, have included paints and oils, inks and paper, mirrors and installations, imagescapes that oftentimes verge upon abstract compositions, vestiges

of bold human forms placed within, and through, densely writhing colourscapes. Often Noé *père* is connected to the artistic template of new- or neo-figuration, *Nueva Figuración*, associated after the 1950s with other artists such as Eduardo Arroyo, Antonio Berni and Veronica Ruiz de Velasco. This group embraces heavily saturated and abstract frames, condensed with texture and mass, in which the human body still registers as a lingering repository or after-echo; a fascinating fusion or composite, in other words, between non-figurative avant-garde modernism and more conventional representational art. As Mercedes Casanegra suggests, these artists rallied collectively around a radicalized new artistic treatment of the human being, opposed to traditional Renaissance perspectives yet retaining the nude as focal point. Hence through 'multiple oppositions and dialectical syntheses…the figure was opened up and rendered through the lyrical transcription of the states of the soul' (2010). In August 1961, exhibiting collectively in Buenos Aires, Noé and a group of peers published a manifesto which in part declared, 'We are a group of painters who, in our expressive freedom, feel the need to incorporate the freedom of the figure' (Casanegra, 2010). In paintings like *La anarquia del ano XX* (The anarchy of the year XX, 1961) and *Introducción a la esperanza* (Introduction to hope, 1963), Noé senior's work oscillates between dark, despairing expressive modes, consternation and anguish, but also occasional tinges of neutral contemplation, occasionally a facial trace indicative of something resolutely anticipative, enthused and hopeful.

In contradiction to his constraining (and hazily or pejoratively concocted) reputation as merely a combative film-maker, Noé *fils* regularly explores through cinema these kinds of corporeal states, painterly new figurations: bodies aghast, but also bodies euphoric. In several interviews, Noé directly cited his father's work, hailing him as a source of inspiration both artistic and paternal; he even went so far as to commission some of Noé *père*'s more psychedelic, fluorescent canvases for the mise-en-scène of scenes in *Enter the Void*; others hang on the wall of Alex and Marcus's Paris apartment, revealed, and counterposed, as the couple banter and dance there

together (Le-Tan, 2009). Figurations also underwrite Noé's collaborations with Debie, their mutual fixation upon making light tangible, colour irradiant, centred upon the human body, nude or partially nude, as a source of representational energy. The shots of Alex and Marcus negotiating the upstairs party space in segment 9, with multiplying iridescent spotlights trained on the contours of Cassel and Bellucci's bodies, playing over their forms, cinematically highlight this mise-en-scène. But returning to Alex awakening atop Marcus two segments later, we do need to reconceive *Irreversible*'s finale, for the first time, as a series of tableaux vivants, of figurations of corporeal harmony, romantic fulfilment, of physical ecstasy.

Noé's camera often instantiates velocity and diegetic threat; it can also amplify calm, slowness and sumptuous existence. Segment 11 opens inside Marcus and Alex's apartment: their bedside telephone rings; Marcus drowsily swats at it with a pillow, trying to shut it up, irritable at being interrupted, at this breaking of the mood. The camera pans right, in response, pointedly ignoring Pierre's voice glumly reporting the breakdown of his car – the instigating source of *Irreversible*'s tribulations, after all, is as humdrum as a cheap car's broken engine – and we contemplate the

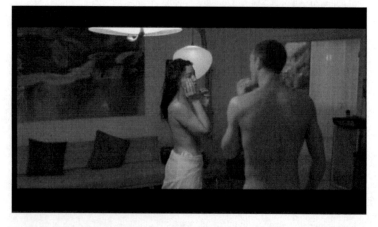

Figure 19: Figurations: Alex and Marcus in domestic and corporeal comfort in segment 11

couple's bodies, stationary, bathed in autumnal fill light. Concomitant to the representation of the central star-couple reunified, as we saw earlier, is Noé's extraordinary figuration here of Bellucci in three-quarter view, in exuberant repose. There next come 40 seconds of poignantly sustained silence: Bellucci, Noé's nude, simply breathes in and out, as tiny ripples run up and down her spine; she sighs, she shivers; delicate clenches of her shoulder muscles gently undulate the flow of Debie's lighting, like diffuse late-summer sunbeams dancing on water. At peace, prolonged, the shot savours pure texture, flesh hues and skin tones, a colour spectrum from soft amber to salmon-orange, pinkish tenné to creamy white. This is visual, corporeal rhapsody, punctuated eventually by Alex's opening line: 'I had a dream'. Here there is a conscious echo of traumas past, but reformulated into waking revelry, a litany of almost musical pleasures of the body, like the gorgeous bittersweet moving still life studies in French Impressionist films of the 1920s: films that, like *Irreversible*, oscillate aesthetically between transcendent beauty and the prospect of sudden dire violence, such as *The Smiling Madame Beudet* (1922), *Ménilmontant* and *The Three-Sided Mirror* (1927). The upshot of this tableau, alongside and underlying Alex and Marcus's play, is that she is pregnant, that the possibility exists here of a third body, the product of these two, emanating from this woman, and a different kind of dream.

The refrain of these culminating segments, Noé's closing corporeal figuration, is to continue alongside Bellucci, after Alex has kissed Marcus goodbye, and leave her finally, contentedly, by herself: at one, with child, then at one with the world around her. *Irreversible*'s final suite is of intimate domestic gestures: Alex washing her hair, enjoying the shower's play of water across her face and front, wrapping herself carefully in a white towel, studying her tranquil reflection in a mirror, then using on the toilet a pregnancy test, which she has unpacked from the bathroom cabinet. Noé's applied cinephilia here channels Chantal Akerman's *Jeanne Dielman, 23 Quai de Commerce, 1080 Bruxelles* (1975), distantly reviving its study of measured household rhythms, especially the scene of Jeanne (Delphine Seyrig) washing her body with soap in a bathtub, dressing, then scrubbing

that same bathtub clean. Jeanne's movements – Ivone Margulies calls them Akerman's 'excess of detail', the fabric of the Akerman's film's 'uncanny tour of domestic bliss' (1996, pp. 90, 91) – are physical banalities attended to at length, on their own terms, yet at once they also exalt this humdrum ordinary and everyday, elevate the chores into something grandiose, physically and psychologically momentous.

At this discursive juncture, Alex embodies the totality of *Irreversible*'s rising orchestrations: from the sofa where her pregnant state is confirmed, imbuing her with delight and profound introspection; to her sleeping in bed alone, cradling her belly, under Stanley Kubrick's Star Child's portentous gaze; to her dazzling final appearance in a park, amidst the sights and songs of utopian social space. Alex here climactically surpasses the role of *flâneuse* – the surrounding world comes to her now, parading exponentially its spectrum of stimuli. Ludwig van Beethoven's Seventh Symphony accompanies the concluding images, one of the most spectacular of all the *cinéma du corps*: these conditions of physical idyll, Alex lying beside a child flying a pink kite around a gushing park sprinkler, then onwards, up into the sky, and apparently out past even that. For its closing minute

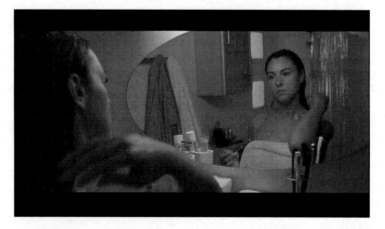

Figure 20: Studies of Alex, in segment 11

Irreversible next stylistically disperses: from string music into raw noise, legible images into flickers of animated light, bodies into atoms, composite materials dissolving and erupting into a slew of their constituting elements. The film's final figuration, then, is of humanity reduced to, and yet also inflated by, the sum of its precious parts; the materials of cinema itself scattering and disassembling into nothingness, pure aesthetics. This is Noé's profound poise, begun with Bellucci's body: from horrible confinement in an underground space to this accelerating flight into and through the sky, from violent physical specificity to ineffable perceptual rapture.

✖ CONCLUSION

Any summary of *Irreversible* – a film which literally tries to leave us unmoored, dizzy, launching us off into uncharted open space in its final shots – must recognize that it is constitutionally driven by inversions, laced with forcefully ironic new permutations of things we thought, or assumed, that we already knew. However you approach Gaspar Noé's film – to admire it or denigrate it, to consider it objectively or try to rip it apart – this is a film fiercely committed to pulling the rug out from beneath you, to outmanoeuvre and outflank you, to force you to regroup and rethink, at some conclusive moment to try to lick your wounds. Wherever you look, and listen, the sights and sounds of Noé's diegetic world are radically unstable. Nowhere is safe, nothing is sacrosanct: *Irreversible*'s subversions extend from its disconcerting use of an iconic trio of star performers; to its battering down the wall between avant-garde experiments and conventional narrative designs; to using film style to assault but also to aggrandize beauty; to turning the world's most beloved filmed city, Paris, into a liminal arena of fear; to holding up a harsh distorting mirror to the animalistic underbelly of the civilized industrial world; to taking us from the most hideous of physical degradations to the most utopian statements of corporeal bliss and union between lovers, between nascent parents. Whether you are a casual viewer or a seasoned film-maker, a veteran critic or a fledgling academic, *Irreversible* wants to send you back to the mental drawing board, to deconstruct your overriding sense of blasé superiority about film, to make you feel exposed and vulnerable, conceptually outgunned by, of all things, a piece of cinema.

The easy response to such a pre-eminently controversial film as *Irreversible* is to want to brush it aside, to look the other way, actively or unconsciously to marginalize it. Yet what this book has argued is that Noé's production is actually a pivotal, representative, even flagship film for the brilliant, fast-paced ecosystem of contemporary French cinema, which remains one of the world's leading centres of, and generative sources for, world film production. Noé gazes caustically yet also fascinatedly at France, estranged by his status as an objectively appraising immigrant, yet also profoundly integrated into the shaping currents of French film

culture through his kinship with the flourishing *cinéma du corps* around him. More broadly, Noé himself embodies – like the Butcher in *Carne* and *I Stand Alone*, like Marcus and even Pierre and Alex in *Irreversible* – a composite personality that is profoundly, painfully relevant to the unreliable and turbulent international world of the early twenty-first century. The bewildering Paris of *Irreversible* resonates with the dualities of this contemporary life: people's capacity to be enraptured by others but also to dominate and exploit them; the latent competitive (and acquisitive) violence that lurks within our sometimes fraught social and economic systems; an ever-growing population density that creates personal affinities but also arouses a predatory instinct among stressed, animalistic humans; spreading cityscapes in which energizing splendour and corrupting barbarity are innate neighbours, like a signposted blood-red underpass beneath a busy city road. Part of *Irreversible*'s ultimate repulsive appeal, its bravura odious charm, is that, within its textual wreckage, its twisted new configurations of recognizable film forms, there really is, like it or not, something in there for everyone. Most world cinema (even that small contingent which is indignant) is omnisciently smug and smugly omniscient – it wants to perch rose-tinted spectacles comfortably on our noses, either to reassure us, or else didactically preach to the choir. But *Irreversible* insists that we must – sceptically, kinetically, defiantly – look for ourselves, and at least endeavour to make partial sense of the chaos. Or, to reiterate a famous formulation applied by André Bazin to *Bicycle Thieves*, *Irreversible*'s distant ancestor, Noé will stand for nothing less than to remove the grime from those eyes, forcing us to see, and consider, anew.

And on a final note, is it not better, more inspiring, to reconceive of controversy – and however we disagree we might certainly come together on the point that *Irreversible* will forever be controversial – as being at its best, its most considered, a tool for drastic renewal, for reimagining inherited leftovers, reinventing cultural detritus? Certainly there is a case that after the late 1990s *Irreversible* and its *cinéma du corps* cohorts, in a spirited conversation of raised and incisive voices, returned French cinema from

marginality, the creative doldrums, back to a position of supremacy – the French film ecosystem as a place that you simply needed to reckon with. As such, Noé's ultimate goal with *Irreversible*, the point to all this firestorm, might be a fervent uncompromising plea for reinvention: of textual forms, of the production complex within which an artist moves, and, of, in due course, the terminal apex of all this – of the viewer's role, to make that viewer work harder, to rethink their position once again. Avoid complacency, Noé demands – strive. We might boil all of this energy down to a single formulation to encapsulate Gaspar Noé's contribution to contemporary French, and world cinema, with *Irreversible*. Time destroys all things, this most committed and unsettling of film-makers insists, but by embracing that destruction comes rebirth.

✖ APPENDIX

Appendix: Key Details

Cast

Alex	Monica Bellucci	Layde	Hellal
Marcus	Vincent Cassel	Commissaire	Nato
Pierre	Albert Dupontel	Taxi Driver	Fesche
Le Tenia	Jo Prestia	Concha	Jaramillo
The Man	Philippe Nahon	Inspector	Le Quellec
Stéphane	Stéphane Drouot	Isabelle	Isabelle Giami
Fistman	Jean-Louis Costes	Fatima	Fatima Adoum
Mick	Michel Gondoin	Rectum Client	Gaspar Noé (uncredited)
Mourad	Mourad		

Production Crew

Director	Gaspar Noé		
Producer	Christophe Rossignon	Production Designer	Alain Juteau
Written by	Gaspar Noé	Editor	Gaspar Noé
Co-Producers	Vincent Cassel	Special Make-Up Effects	Jean-Christophe
	Brahim Chioua		Spadaccini
	Richard Grandpierre	Original Music	Thomas Bangalter
	Gaspar Noé	Costume Designer	Laure Culkovic
Directors of	Gaspar Noé (credited with	Casting	Jacques Grant
Photography	"Camera")		
	Benoît Debie (credited with		
	"Lighting")		

Other Details

Filmed on location in Paris. Shooting commenced 15 July 2001 and finished 30 August 2001.
Released: 23 May 2002 (France).
Budget: 4.61 million euros.
Admissions: 553,415 in France.
Runtime: 97 minutes.

Awards

Nominated for Palme d'Or, 2002.
Won Bronze Horse, Stockholm Film Festival, 2002.
Runner-up, Boston Society of Film Critics Awards, 2003: Best Cinematography, Best Foreign Language Film.
Won Best Foreign Language Film, San Diego Film Critics Society Awards, 2003.
Nominated for Best Foreign Language Film, Film Critics of Australia, 2004.

Certification and Ratings

Argentina: 18
Australia: R
Austria: 18
Brazil: 18
Canada: R
Canada: 18+ (Québec)
Denmark: 15
Finland: K-18
France: -16
Germany: 18
Hong Kong: III (*cut version*)
Iceland: 16
Ireland: 18
Italy:VM18
Japan: R-18
Malaysia: Banned
Mexico: C
Netherlands: 16
New Zealand: R18
Norway: 18
Peru: 18
Portugal: M/18
Singapore: R(A) (*original rating*); R21 (*re-rating*)
South Korea: 18
Spain: 18
Sweden: 15
Sweden: 18
UK: 18
USA: Not Rated

✖ Bibliography

Anon. BBC coverage (2002) 'Cannes Film Sickens Audience', accessed online 29 August 2013 at http://news.bbc.co.uk/2/hi/entertainment/2008796.stm.

Anon. (2002b) 'Selon vous, à quel film le jury du Festival de Cannes va-t-il attribuer la Palme d'or?', *Le Film français*, May 24, p. 5.

Austin, G. (2003) *Stars in Modern French Film* (London: Arnold).

Austin, G. (2012) 'Biological Dystopias: The Body in Contemporary French Horror Cinema', *L'Esprit Créateur*, 52: 2, Summer, 99–113.

Bailey, M. (2003) 'Gaspar Noé', *Senses of Cinema*, accessed online 24 March 2006 at http://sensesofcinema.com/2003/great-directors/noe/.

Barker, M. (2010) '"Typically French"?: Mediating Screened Rape to British Audiences', in D. Russell, (ed.), *Rape in Art Cinema* (London: Continuum), pp. 145–158.

Bayon, E. (2007) *Le Cinéma obscene* (Paris: L'Harmattan).

Betz, M. (2009) *Beyond the Subtitle: Remapping European Art Cinema* (Minneapolis: University of Minnesota Press).

Beugnet, M. (2007) *Cinema and Sensation: French Film and the Art of Transgression* (Edinburgh: Edinburgh University Press).

Block, M., ed., (2011) *World Film Locations: Paris* (Bristol: Intellect).

Bordwell, D. (2005) *Figures Traced in Light: On Cinematic Staging* (Berkeley: University of California Press).

Brottman, M. and Sterritt, D. (2004) '*Irreversible*', *Film Quarterly*, 57:2, 37–42.

Buchsbaum, J. (2005) ' After GATT: Has the Revival of French Cinema Ended?', *French Politics, Culture and Society*, 23:3, 34–54.

Burnett, C. (2013) 'Cinema(s) of Quality', in T. Palmer and C. Michael (eds.), *Directory of World Cinema: France* (Bristol: Intellect), pp. 140–148.

Busca, J.-P. (2002) 'Le Couple Bellucci–Cassel', *Le Film français*, May 10, p. 55.

Cairns, L. (2000) 'Sexual Fault Lines: Sex and Gender in the Cultural Context', in W. Kidd and S. Reynolds (eds) *Contemporary French Cultural Studies* (London: Arnold), pp. 81–94.

Casanegra, M. (2010) 'New Figuration, Notes Fifty Years Later', Museo Nacional de Bellas Artes, accessed online 29 August 2013 at www.artindexargentina.com/museums/mnba/nueva-figuracion/new-figuration-1961–1965.

Cavell, S. (1981) *Pursuits of Happiness: The Hollywood Comedy of Remarriage* (Cambridge: Harvard University Press).

Célestin, R., DalMolin, E., and de Courtivron, I. (2003) 'Introduction', in R. Célestin, E. DalMolin, and I. de Courtivron (eds), *Beyond French Feminisms: Debates on Women, Politics and Culture in France, 1981–2001* (New York: Palgrave Macmillan).

Centre National du Cinéma et de l'Image Animée (2002) 'Dossier #287 Bilan 2002', accessed online 4 September 2013 at http://cnc.fr/web/fr/detail_ressource?p_p_auth=EKslZn6x&p_p_id=ressources_WAR_ressourcesportlet&p_p_lifecycle=0&p_p_state=normal&p_p_mode=view&_ressources_WAR_ressourcesportlet_struts_action=%2Fsdk%2Fressources%2Fview_document&_ressources_WAR_ressourcesportlet_entryId=17537&_ressources_WAR_ressourcesportlet_redirect=%2Fweb%2Ffr%2Findex%3Fp_p_auth%3DGLp3lXuO%26p_p_id%3D3%26p_p_lifecycle%3D0%26p_p_state%3Dmaximized%26p_p_mode%3Dview%26_3_struts_action%3D%252Fsearch%252Fsearch%26_3_keywords%3D2002+287.

Centre National du Cinéma et de l'Image Animée (2002) *La Production cinématographique en 2002*, accessed online 4 September 2013 at http://cnc.fr/web/fr/detail_ressource?p_p_auth=7uazHH4D&p_p_id=ressources_WAR_ressourcesportlet&p_p_lifecycle=0&p_p_state=normal&p_p_mode=view&_ressources_WAR_ressourcesportlet_struts_action=%2Fsdk%2Fressources%2Fview_document&_ressources_WAR_ressourcesportlet_EntryId=19937&_ressources_WAR_ressourcesportlet_redirect=%2Fweb%2Ffr%2Findex%3Fp_p_auth%3DBw7V9l0T%26p_p_id%3D3%26p_p_lifecycle%3D0%26p_p_state%3Dmaximized%26p_p_mode%3Dview%26p_p_col_count%3D1%26_3_struts_action%3D%252Fsearch%252Fsearch%26_3_keywords%3D2002.

Chamarette, J. (2011) 'Shadows of Being in *Sombre*: Archetypes, Wolf-Men and Bare Life', in T. Horeck and T. Kendall (eds), *The New Extremism in Cinema: From France to Europe* (Edinburgh: Edinburgh University Press), pp. 69–81.

Club des 13, Le (2008) *Le Milieu n'est plus un pont mais une faille* (Paris: Éditions Stock).

Coulthard, L. (2010) 'Uncanny Horrors: Male Rape in Bruno Dumont's *Twentynine Palms*', in D. Russell (ed.), *Rape in Art Cinema* (London: Continuum), pp. 171–184.

Cox, D. (2009) 'Masterclass with Gaspar Noé', accessed online 10 September 2013 at http://www.bfi.org.uk/live/video/90.

Creton, L. (2005) *L'Économie du cinéma* (Paris: Armand Colin).

Crisp, C. (2003) *The Classic French Cinema, 1930–1960* (Bloomington: Indiana University Press).

Deleuze, G. (1989), trans. H. Tomlinson and R. Galeta, *Cinema 2: The Time-Image* (London: Athlone Press).

Delorme, G. (2009) 'Pourquoi Vincent Cassel est-il aussi fort à l'export?' *Première*, September, 24.

Dunne, J. W. (2001) *An Experiment in Time* (Newburyport, MA: Hampton Roads; originally published in 1927).

Ebert, R. (2003), '*Irreversible*', March 14, accessed online 2 September 2013 at http://www.rogerebert.com/reviews/irreversible-2003.

Elsaesser, T. (2005) *European Cinema: Face to Face with Hollywood* (Amsterdam: Amsterdam University Press).

Ezra, E. (2008) *Jean-Pierre Jeunet* (Chicago: University of Illinois Press).

Falcon, R. (1999) 'Reality is Too Shocking', *Sight & Sound* 9:1, 10–14.

Feuillère, A. (2006) 'Benoît Debie, directeur photo,' *Cinergie Webzine*, May 5, accessed online 9 September 2013 at http://www.cinergie.be/webzine/benoit_debie_directeur_photo.

Fougère, R., Pouget, J. and Kramarz, F. (2009) 'Youth Unemployment and Crime in France', *Journal of the European Economic Association*, 7:5 September, 909–938.

Frater, P. (2002) 'Irreversible Wins Shock Value But No Awards', *Screen Daily*, May 26, accessed online 17 September 2013 at http://www.screendaily.com/irreversible-wins-shock-value-but-no-awards/409423.article.

Frodon, J.-M. (2004) *Le Cinéma sans la television: le Banquet imaginaire/2* (Paris: Gallimard).

Gimello-Mesplomb, F. (2011) 'Le Prix à la qualité: L'État et le cinéma français (1960–1965)', *Politix*, 16:61, 97–115.

Gorin, F. (2002) '*Irréversible*', *Télérama*, May 22.

Gorin, F. and Rigoulet, L. (2002) 'Ce sont les plus tordus qui s'en sortent', *Télérama*, May 22.

Grant, P. D. (2013) 'Avant-Garde', in T. Palmer and C. Michael (eds), *Directory of World Cinema: France*, pp. 100–119.

Hickin, D. (2011) 'Censorship, Reception and the Films of Gaspar Noé: The Emergence of the New Extremism in Britain', in H. Horeck and T. Kendall (eds), *The New Extremism in Cinema: From France to Europe* (Edinburgh: Edinburgh University Press), pp. 117–129.

Hill, J. (2010) 'Pyramid Texts', accessed online 4 August 2013 at http://www.ancient-egyptonline.co.uk/pyramidtext.html.

Holohan, C. (2010) 'Aesthetics of Intimacy', *Short Film Studies*, 1:1, 87–90.

Horeck, H. and Kendall, T., eds. (2011) *The New Extremism in Cinema: From France to Europe* (Edinburgh: Edinburgh University Press).

Jackel, A. (2013) 'Comedy', in Palmer, T. and Michael, C. (eds) (2013) *Directory of World Cinema: France* (Bristol: Intellect), pp. 242–251.

James, N. (2002) '*Irreversible* Cannes Report', *Sight and Sound*, 12:7, 12–16.

Jameson, A. D. (2011) 'Art as Inheritance, part 3: Reverse Chronology', May 25, accessed online 10 August 2013 at http://bigother.com/2011/05/25/art-as-inheritance-part-3-reverse-chronology/.

Jullier, L. and Mazdon, L. (2004) 'Technology 1960–2004: From Images of the World to the World of Images', in M. Temple and M. Witt (eds), *The French Cinema Book* (London: BFI), pp. 221–230.

Kaganski, S. (2001) 'Amélie pas jolie', *Libération*, May 31.

Kaganski, S. (2002) 'Monica Bellucci/Vincent Cassel/Gaspar Noé: *Irrréversible*', *Les Inrockuptibles*, May 15.

Kaganski, S. and Bonnaud, F. (2001) 'Tendre est la nuit: Entretien avec Claire Denis', *Les Inrockuptibles*, July 11.

Keesey, D. (2010), 'Split Identification: Representations of Rape in Gaspar Noé's *Irréversible* and Catherine Breillat's *A ma soeur!/Fat Girl*', *Studies in European Cinema*, 7:2, 95–107.

Kidd, W. and Reynolds, S. (eds), (2000) *Contemporary French Cultural Studies* (London: Arnold).

Konstantarakos, M. (1999) 'Which Mapping of the City? *La Haine* (Kassovitz 1995) and the *Cinéma du Banlieue*', in P. Powrie (ed.), *French Cinema in the 1990s: Continuity and Difference* (Oxford: Oxford University Press).

Lalanne, J.-M. (2002) '*Irréversible*', *Cahiers du cinéma*, June, p. 51.

Lançon, P. (2001) 'Le Frauduleux destin d'Amélie Poulain', *Libération*, June 1.

Lavoignat, J.-P. (2005) 'Bellucci putain de fille!' *Studio*, 210, March, 56–69.

Le-Tan, O. (2009), 'Gaspar Noé: Interview', *Purple Fashion Magazine*, 11, accessed online 1 September 2013 at http://purple.fr/magazine/s-s-2009-issue-11/article/240.

Levy, C. (2013) 'Benoît Debie: Eclairer "the beauty of ugliness"', *Sortie d'usine*, June 11, accessed online 28 August 2013 at www.sortiedusine.org/2013/06/11/benoit-debie-eclairer-the-beauty-of-ugliness/.

Mackenzie, S. (2010) 'On Watching and Turning Away: Ono's *Rape*, *Cinéma Direct* Aesthetics, and the Genealogy of *Cinéma Brut*', in D. Russell (ed.), *Rape in Art Cinema* (London: Continuum), pp. 159–170.

Marie, M. (2009) 'French Cinema in the New Century', *Yale French Studies*, 115, 9–30.

Margulies, I. (1996) *Nothing Happens: Chantal Akerman's Hyperrealist Everyday* (Durham: Duke University Press).

Matsuda, M. (1996) *The Memory of the Modern* (Oxford: Oxford University Press).

McCann, B. (2013) 'Horror', in T. Palmer and C. Michael (eds), *Directory of World Cinema: France* (Bristol: Intellect), pp. 276–283.

Michael, C. (2005) 'French National Cinema and the Martial Arts Blockbuster', *French Culture, Politics and Society*, 23:3, 55–74.

Michael, C. (2013) 'Star Study: Albert Dupontel', in T. Palmer and C. Michael (eds), *Directory of World Cinema: France* (Bristol: Intellect), pp. 21–24.

Michelson, A. (1971) 'Toward Snow', *Artforum*, 11.1, 30–37.

Mitchell, R. (2002) 'Edinburgh: *Irreversible* Director Noé Lays Down Challenge to UK Censors', August 19, accessed online 14 September 2013 at www.screendaily.com/edinburgh-irreversible-director-noe-lays-down-challenge-to-uk-censors/4010192.article.

Naremore, J. (1988) *Acting in the Cinema* (Berkeley: University of California Press).

Neupert, R. (2011) *French Animation History* (Chichester: Wiley-Blackwell).

Oscherwitz, D. (2010) *Past Forward: French Cinema and the Post-Colonial Heritage* (Carbondale: Southern Illinois University Press).

Oscherwitz, D. (2011) 'Shaking up the Historical (Film): Christophe Gans's *Le Pacte des loups/The Brotherhood of the Wolf* (2001)', *Studies in French Cinema*, 11:1, 43–55.

Palmer, T. (2006a) 'Style and Sensation in the Contemporary French Cinema of the Body', *Journal of Film and Video*, 58:3, 22–32.

Palmer, T. (2006b) 'Under Your Skin: Marina de Van and the Contemporary French *Cinéma du corps*', *Studies in French Cinema*, 6:3, 171–181.

Palmer, T. (2008) 'Star, Interrupted: The Reinvention of James Stewart', in K.-P. Hart (ed.), *Film and Television Stardom* (Cambridge: Cambridge Scholars Publishing), pp. 43–57.

Palmer, T. (2010) 'Don't Look Back: An Interview with Marina de Van', *The French Review*, 83:5, 96–103.

Palmer, T. (2011) *Brutal Intimacy: Analyzing Contemporary French Cinema* (Middleton, CT: Wesleyan University Press).

Palmer, T. (2012a) 'Crashing the Millionaires' Club: Popular Women's Cinema in Twenty-First Century France', *Studies in French Cinema*, 12:3, 201–214.

Palmer, T. (2012b) 'Rites of Passing: Conceptual Nihilism in Jean Paul Civeyrac's *Des filles en noir*', *Cinephile*, 8:2, Fall, 8–15.

Palmer, T. (2013a) 'Women Filmmakers in France', in T. Palmer and C. Michael (eds), *Directory of World Cinema: France* (Bristol: Intellect), pp. 64–75.

Palmer, T. (2013b) Personal interview with Carine Tardieu, Paris, France, July 18.

Palmer, T. (2014) 'Modes of Masculinity in Contemporary French Cinema', in R. Moine, H. Radner, A. Fox and M. Marie, (eds), *A Companion to Contemporary French Cinema* (Chichester: Wiley-Blackwell).

Palmer, T. and Michael, C. (eds) (2013) *Directory of World Cinema: France* (Bristol: Intellect).

Pellerin, D. (2002), '*Irréversible*: Mise en perspective', *Séquences*, September–October, 221–222.

Perkins, V. F. (1972) *Film as Film: Understanding and Judging Movies* (London: Penguin).

Peterson, J. (1994) *Dreams of Chaos, Visions of Order: Understanding the American Avant-Garde Cinema* (Detroit: Wayne State University Press).

Pinker, S. (2011) *The Better Angels of Our Nature: Why Violence Has Declined* (New York: Viking).

Powrie, P., (ed.) (1999) *French Cinema in the 1990s: Continuity and Difference* (Oxford: Oxford University Press).

Reuters News (2002) 'Irreversible sends shock waves through Cannes', *Expressindia*, May 25, accessed online 23 August 2013 at http://expressindia.indianexpress.com/news/fullstory.php?newsid=10773.

Romney, J. (2004) 'Le Sex and Violence', *The Independent*, 12 September, accessed online 4 June 2013 at http://www.independent.co.uk/arts-entertainment/films/features/le-sex-and-violence-6161908.html.

Rosenbaum, J. (2003) 'All and Nothing: *Irreversible* & *Amen*', *The Chicago Reader*, March 14, accessed online 4 May 2013 at www.jonathanrosenbaum.com/?p=6154.

Rouyer, P. (2002) 'Irréversible: Bonheur perdu', Positif, July-August, 113–114.

Rouyer, P. and Vassé, C. (2004) 'Entretien avec François Ozon: La Vérité des corps', Positif, 502, July/August, 43–44.

Russell, D. (2010) 'Introduction: Why Rape?', in D. Russell (ed.), Rape in Art Cinema (London: Continuum),

Said, S. F. (2002) 'Edinburgh reports: Outback Odyssey Packs a Powerful Emotional Punch', The Telegraph, August 20, accessed online 12 September 2013 at www.telegraph.co.uk/culture/film/3581728/Edinburgh-reports-outback-odyssey-packs-a-powerful-emotional-punch.html.

Sitney, P. A. (2008), Eyes Upside Down: Visionary Filmmakers and the Heritage of Emerson (Oxford: Oxford University Press).

Smith, A. (2005) French Cinema in the 1970s: The Echoes of May (Manchester: Manchester University Press).

Sterritt, D. (2007) '"Time Destroys All Things": An Interview with Gaspar Noé', Quarterly Review of Film and Video, 24, 307–316.

Tarr, C. (2005) Reframing Difference: Beur and banlieue Filmmaking in France (Manchester: Manchester University Press).

Tarr, C. (2006) 'Director's Cuts: The Aesthetics of Self-Harming in Marina de Van's Dans Ma Peau', Nottingham French Studies, 45:3, 78–91.

Tarr, C. (2012) 'Introduction: Women's Filmmaking in France 2000–2010', Studies in French Cinema, 12:3, 189–200.

Tarr, C., with Rollet, B. (2001) Cinema and the Second Sex: Women's Filmmaking in France in the 1980s and 1990s (New York: Continuum).

Torreo, E. (2003) 'Tunnel Visionary: Gaspar Noé's Brutal Irreversible', accessed online 4 September 2013 at www.indiewire.com/article/decade_gasper_noe_on_irreversible.

Valens, G. (2002) 'Irréversible: Irresponsable', Positif, July–August, 111–112.

Vanderschelden, I. (2008) 'Luc Besson's Ambition: EuropaCorp as a European Major for the 21st Century', Studies in European Cinema, 5:2, 91–104.

Vanderschelden, I. (2009) 'The "*Cinéma du milieu*" is Falling Down: New Challenges for Auteur and Independent French Cinema in the 2000s', *Studies in French Cinema*, 9:3, 243–257.

Vincendeau, G. (2000) *Stars and Stardom in French Cinema* (London: Continuum).

Vincendeau, G. (2001) 'Café Society', *Sight and Sound*, 11.8, 22–25.

Williams, L. (2008) *Cinema and the Sex Act* (Durham: Duke University Press).

Willis, H. (2003) 'Brutal Genius', *Res*, July/August, 7–13.

Wood, R. (2003) '*Irreversible*: Against and For', *Film International*, 1:5, accessed online 14 June 2013 at http://filmint.nu/?p=1475.

✖ Index

$12 \times 28 : 336$

$6 \times 7 : 42$

28

$7 \times 4 : 406$

Made in United States
North Haven, CT
01 April 2024

50761449R00107